A HISTORY OF THE

NEW HAMPSHIRE
ABENAKI

BRUCE D. HEALD, PhD

Charleston London

THE
History
PRESS

Published by The History Press
Charleston, SC 29403
www.historypress.net

First published 2014

Manufactured in the United States

ISBN 978.1.62619.422.9

Library of Congress CIP data applied for.

*To Chief Stephen Laurent,
Hereditary Chief of the Abenaki Indians*

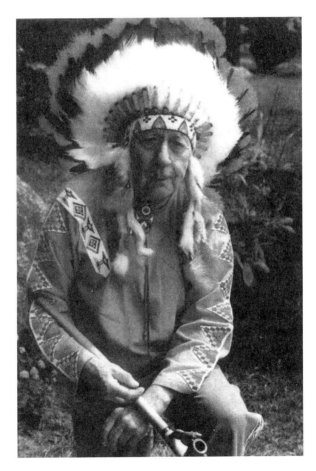

Chief Stephen Laurent (Atian Lolo), lexicographer of the
Abenaki. *Courtesy of Stephen Laurent and Charles R. Huntoon.*

CONTENTS

Foreword, by Réjean Obomsawin 7
Acknowledgements 11
Address, by Chief Donald Stevens 13
Introduction 15

1. The Abenakis and Sokokis 19
2. Language of the New Hampshire Indians 44
3. Indian Warfare 62
4. Indian Legends and Folklore 90

Appendix 111
Bibliography 121
Index 125
About the Author 128

FOREWORD

Historian Dr. Bruce Heald's task for this book is very important for my people of the Wobanaki Confederacy, who are still living on our ancestral territory on the East Coast of North America. Often history puts aside important factors and details that are crucial to give a more realistic picture of many events that are the roots of the Europeans' settlements in America. We, the Abenakis and Sokokis, were among the first indigenous people to encounter the Europeans prior to the arrival of Christopher Columbus on the shore of the New World. From that day in the states of North and South Carolina to Newfoundland, the Wobanaki Confederacy nations maintained strongholds to protect our ancestral territories from European invasions.

The Jesuits and the French forces looked forward to building alliances and used my people's knowledge of the territories to their advantage against the English military forces and their indigenous allies. The harsh reality is that the indigenous nations were used as buffers between the two European forces not only in direct combat but also from the biological warfare that decimated more than 90 percent of the Native American population in North America. This book could change the view of what really took place in history and give respect to the memories of our ancestors who lived and died here for thousands of years.

May Kchi Niwaskw ("creator of life"), bless you and your families, open your hearts and minds to understand the pains and struggles of our people then and now and look for better future for relationships between our respective nations.

Rejean Obomsawin
Abenaki Museum of the Odanak Indian Reservation
Quebec, Canada

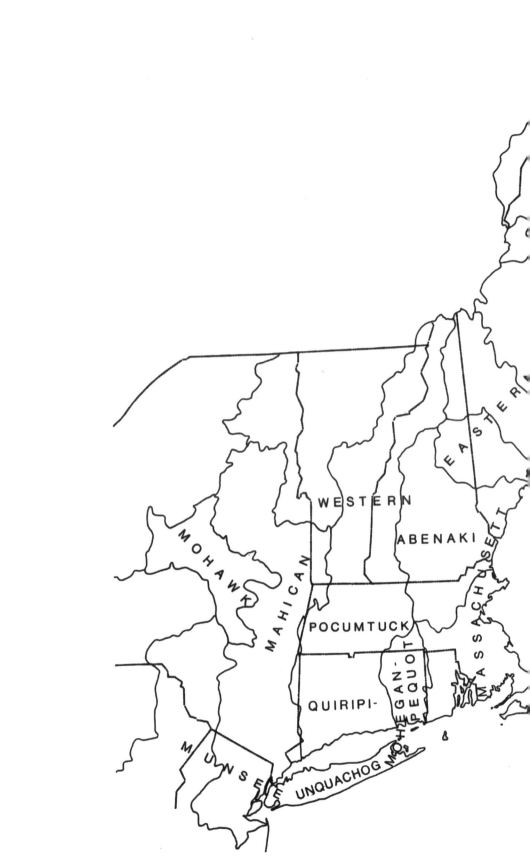

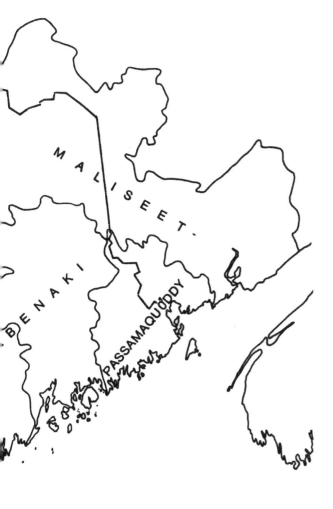

Map of the distribution of major cultural units in aboriginal New England, circa AD 1600. Each major language is written on the map in the region in which it was spoken. Subdivisions and names that came into use in later times are not shown. *Courtesy of the author.*

ACKNOWLEDGEMENTS

Michelle Belanger, directrice generale, Musée des Abénakis "Odanak," Quebec; Dr. Krisan Evanson; Solon B. Colby; Elsie Floyd Davis; Elsie Farren; Grace Fraser; Genevieve from Odanak Village, Quebec; M.B. Goodwin; Deborah Herrington; Alice K. Hill; Dorsey W. Hyde; Alice Morrill; Nashua Historical Society, Nashua, New Hampshire; New Boston Chapter DAR; *New England Gazeteer*; Réjean OBomsawin; Ossipee Historical Society, Ossipee, New Hampshire; Penecook Historical Society, Penacook, New Hampshire; Chester B. Price, St. Francis, Odanak Village Museum, Quebec; Enzo Serrafini; John Spaulding; Donald Stevens; Margery Sullivan; Dover Chapter DAR, Dover, New Hampshire; Elsie Warren; Edgar H. Wilcomb; and Reverend Stephan Williams.

ADDRESS

G reetings,

Our people were once as plenty as the trees in the forest, and now we are but a small grove in the meadow. As leaders, we must maintain deep roots to our past and bend with the changing winds of the future. We must stand strong like the mighty oak that provides shelter against the elements to preserve our culture and our way of life. As our children grow and fall from our limbs, we hope that they will take root in our culture and carry it on to the next generation. If they do not, then we will surely parish as a people and be only a distant memory in the great tree of life.

Through all the suffering our people have endured, there is always hope for future generations. The western Abenaki people still have a foothold in our ancient homelands in New England and Canada. Vermont has recognized our western Abenaki tribes in the United States, and we have citizens throughout New England and Canada who still roam the woods of our ancestors. Some of us stayed behind after the wars to continue to protect our ancestral homelands and the southern flank of our allies to the north.

One of my duties as chief is to help in the education of our history and culture to all who want to listen. Without education, there is only ignorance left in its place. This book helps in that responsibility, and I thank Dr. Bruce Heald for allowing me to review and be a part of this process.

My hope for the future is one of peace, unity as a people and cooperation with all nations. In togetherness there is strength and the ability to secure a lasting future for the Abenaki people.

CHIEF DONALD STEVENS
Nulhegan Band of the Coosuk, Abenaki Nation, Vermont

INTRODUCTION

Two great Indian families (nations) dominated the eastern United States: the Algonquians and the Iroquois. The realm of the Algonquians stretched from the Atlantic Ocean to the Great Lakes and beyond and from the Carolinas to Hudson Bay. Within this massive area of real estate was a small section where the Iroquois ranged and ruled. Although not living in New Hampshire, the Iroquois probably warred in this state against their Algonquian neighbors from Canada and New England. The Indians formerly living in the immediate vicinity of Maine and New Hampshire are known by the name of Abenaki, "Men of the East."

The Abenaki and Pennacook Indians were living in the area of New Hampshire when the Europeans arrived. It is not known who the first European men to explore the area were, but general exploration began in the 1600s. Europeans came to New Hampshire for economic reasons and looking to exploit the resources of the area, especially the forest, furs and fish.

Most historians have generally represented the Native Americans in an odious light, especially when recounting the effects of their ferocity. It behooves us to investigate and reestablish the status of our Native Americans.

When the Europeans began to settle in New England, they came in contact with Algonquian peoples, as they occupied all the country as far west as the Mississippi and as far south as Virginia, with the exception of a section of large territory in New York and a portion of Canada to the north. Here, the Iroquois dominated, known by the English as the Five Nations. They

were enemies of the Algonquians and made up for their smaller population by confederating as a unit in time of war. The New England tribes without exception paid them tribute from time to time.

The French made friends and allies of the Algonquians on the St. Lawrence and, until after the last French and Indian War, used them with deadly effect to keep the English from expanding to the north. North America might have been French to this day but for the fateful battle that Champlain, along with the Abenakis, fought with the Iroquois in 1609 on the shores of the lake that now bears the Frenchman's name but was then called Lake Iroquois. Champlain's Algonquian allies asked him to help, and he gladly joined them in an expedition against the Iroquois. The latter were badly beaten, thus Champlain flattered himself that he had taught them in the future to respect the arms of the French; however, he had made those overlords of the New World enteral enemies of the French and allies of the English. If the English settlements had to face the raids from the Mohawks, as they called the Iroquois, instead of the more peaceful Pequots and Pennacooks, our history might have been written differently.

Within the border of New Hampshire were several tribes who lived at the junction of the Connecticut and Ammonoosuc Rivers and northward: the Piscataquas near Dover, the Sokokis on the upper Saco River, the Ossipees and the Merrimack River tribe, more often known as the Pennacook Confederacy. Members of this confederacy in New Hampshire were the Nashuas, living along the river by that name; the Souhegans on the Souhegan River; the Amoskeags at Manchester; the Pennacooks at Concord; and the Winnipesaukees in Central New Hampshire. Sometimes included are the Coosucs to the north, the Squamscots at Exeter, the Winnecowets at Hampton, the Piscatagas at Portsmouth and the Newichwanocks near Rochester.

The Abenakis are a tribe of the Algonquian-speaking people of northeastern North America. The Abenakis lived in the New England region of the country, Quebec and the Maritimes of Canada, a region called Wabanaki, or "Dawn Land" in the eastern Algonquian language. The Abenakis are one of the five members of the Wabanaki Confederacy.

Before contact with the European settlers, the Abenakis (excluding the Pennacooks and Micmacs) may have numbered forty thousand. However, due to early contact with European fishermen, at least two major epidemics hit the Abenakis during the 1500s: an unknown sickness sometime between 1564 and 1570 and typhus in 1586. The eastern Abenakis lost around five thousand people. The western Abenakis were more isolated and suffered

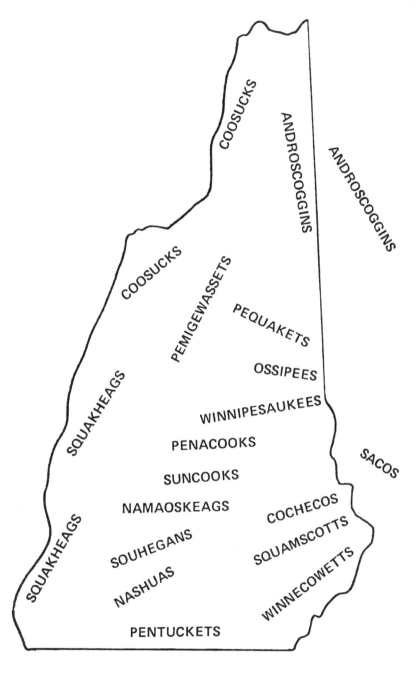

Map of the relative placement of New Hampshire tribes, 1630. New Hampshire Indians numbered fewer than five hundred. Newichewannocks and Piscataquakes had united and were known as Cochecos around 1640. *Courtesy of author.*

relatively less. New diseases—smallpox, influenza and measles—continued to take their tolls. Around 1600, there were nearly fourteen thousand eastern Abenakis and twelve thousand western Abenakis. These diseases reduced these numbers by 78 and 98 percent, respectively, within a few decades.

The Abenaki population continued to decline, but after 1676, it absorbed thousands of refugees from southern New England Algonquian (Pennacook and Pocumtuc) tribes, the ancestors of whom may still be found among the Abenaki, especially the Sokokis (western Abenakis).

Through many years, we might say that providence has now put an end to the controversy of their almost total extirpation. We should therefore proceed with humility toward the past injuries and forming our judgment of the Indian character. Seldom did the early settlers in our nation and state embrace the principal values and refinements of civilized Native American life. It would be difficult to find these people guilty of any crime, a fact that cannot be paralleled among other civilized nations. As historian Jeremy Belknap said, "The Indians were seldom treated with justice and humanity."

There is a mysterious romance in the legacy and folklore of the New Hampshire Indians. It is the intent of this book to celebrate and explore the culture and the trials and tribulations of a vanishing people in America, for they are a people of pride, dedicated to preserving their native heritage and legacy.

According to Hereditary Chief Stephen Laurent (Atian Lolo) of the Abenaki Nation in New Hampshire, "Our voices shall be heard, and our people shall remain as part of the American fabric in the Granite State."

THE ABENAKIS AND SOKOKIS

The early settlers of New England and New France had little in common other than the urge to immigrate. The English were Protestants. The French were Roman Catholics. Their mother tongues were quite different, and it was not surprising that the English and French had altogether different names for identical Indian tribes.

The tribal name of Abenaki was derived from *Wobanaki* ("Land of the East"), the name given by the Canadian Algonguins to the country of the Canibals and other Indians of Acadia. The French called these Indians the Abenaquiois and later Abenakis, which means the "Indians from where the daylight comes" or the "people of the East." This name was first applied to all Native Americans from Maine to Nova Scotia, but later, it was given in particular to those living in Maine from the Saco River to the Penobscot.

The tribal name of Sokoki was derived from *Sokoakiak*, "a person from the south" or "one living under the noon-day sun." It applied to those living between the Saco and Connecticut Rivers, which included most of what is now New Hampshire. The French called them Sokoquiois and later Sokokis.

Their campsites and villages were scattered throughout the state and were known to English merchants and fur traders by Indian names that described the localities in which they lived. For instance, the Coosucks lived at the Pine Place, the Pennacooks at the Crooked Place, the Suncooks at the Rocky Place, the Naticooks at the Cleared Place and so on. As neighbors, the English were much better acquainted with the New Hampshire tribes than the French, who lived two or three hundred miles away.

Under the peaceful leadership of Passaconaway and Wonalancet, the Sokokis did not become involved in either the Pequot War or King Philip's War, which we shall examine later in the chapter on Indian warfare.

During the European colonization of New England, the land occupied by the Abenakis was in the area between the new colonies of England in Massachusetts and those of the French in Quebec. Since no party agreed to territorial boundaries, there were regular conflicts between them. The Abenakis were traditionally allied with the French. During the reign of Louis XIV, Chief S'Assumbuit was designated a member of the French nobility for his service.

Independent of the Abenakis, the chiefs did not take part in the Indian wars of Maine, which ranged from 1676 to 1679. Those who followed their Jesuit missionaries to Canada and founded the village of St. Francis did so from their own choice and not because they were forced out by the English.

The Pestilence of 1616–1618, which resembled yellow fever, was fatal to about 90 percent of the New Hampshire tribes and affected the Maine Indians to the same degree. Up until this time, the Sokokis and Abenakis had more than enough warriors to discourage the Mohawk raids into New Hampshire and the neighboring state of Maine. In 1633, an epidemic of smallpox swept through Maine, New Hampshire and eastern Massachusetts, further weakening the tribes to such an extent that the Mohawks began raiding their villages with little opposition. Because of the infectious diseases, the Abenakis started to migrate to Quebec around 1669. The first was the St. Francis River, which is presently known as the Odanak Indian Village Reservation.

Jesuit missionaries spent considerable time with the Sokokis of New Hampshire between 1650 and 1660; their journeys were largely unsuccessful, especially in the southern part of the state. Diseases and wars provided a continuation of misfortunes for the Abenakis of Maine, but the Sokokis of New Hampshire had another misfortune still worse than those of the Abenakis: they were not acquainted Christianity. The Protestant ministers John Eliot and Thomas Mayhew lived among the Indians and conducted schools for many years. Eliot was always thought of as an apostle to the Indians. He spent much of his time traveling among the tribal villages, reading to them from the Bible, which he had translated into their language.

The New Hampshire Indians suffered more than the Abenakis from Mohawks because they were much nearer to their enemies. Mohawk raids continued to increase until it was no longer safe for the Jesuits to travel from tribe to tribe or carry on the missions. By 1660, the Jesuits had recalled many of their missionaries back to Canada. It was during the 1660s that several

Sokoki families left New Hampshire and founded the village of St. Francis. Some of these people had never been converted by the Jesuit missionaries, but others were nearly ready to receive the sacrament of baptism. At St. Francis, they could bring up their children in the Catholic faith as missions had been established in several nearby communities. There was a mission de loups (wolves) at the Cowass meadows in Haverhill, New Hampshire. They thought they would be able to hunt and fish in Canada without fear of ambush, but it was only a few years until the Mohawks and other Iroquois tribes began sending large war parties into Canada to kill, loot and take prisoners.

By the 1670s, the Sokokis were well established in St. Francis. In September 1677, a party of Sokokis from St. Francis, some of whom were relatives of Wonalancet, visited Chelmsford and asked him to return with them to St. Francis. They told him "that the war in Maine might continue for some time and he would live better and safer with his friends in Canada." His oldest son and his wife's relatives already lived at St. Francis, so he decided to go and live there with them. Three of the men and their families went with him and stayed at St. Francis until the war with the eastern tribes was over. According to records in the New Hampshire secretary's file in Concord, New Hampshire, Wonalancet was back at Penacook in September 1785 but was no longer the chief of his tribe

This was further reason to believe that the Sokokis were firmly established at St. Francis during the 1670s. At an assembly of the leading citizens of the district in October 1678 to get the opinion on the liquor trade with the Indians, Jean Crevier, whose trading post was located at the village of St. Francis, gave his opinion as follows:

> *If the trade in liquor was not permitted it would do considerable harm to the country, in that the large number of Sokokis who live here, and who acquired the drinking habit from the English, would go back there and deprive the Canadians of the large profit brought in by the trade, not knowing of any disorder from their drunkenness, and if it should happen it would not be because of that since the Ottawas who do not use liquor and are taught by the Jesuit missionaries, commit all sorts of crimes every day, which shows that it is their barbaric disposition which brings them to this wickedness and not the use of liquor.*

The Sokokis who acquired the drinking habit from the English were no doubt from the Pennacook tribe as they lived nearer the settlements than the Coosucks or Pequakets.

Jean Crevier's mention of the large number of Sokokis with whom he traded fur would indicate that they were well established at St. Francis in 1678. They had no parish register until 1687. Previous to that time, their records were kept at Sorel or Three Rivers. Sokoki children were baptized at Sorel as early as April 14, 1676. The first Abenaki infant mentioned was baptized on August 17, 1690.

The Abenakis formed an attachment to the French and their culture, mainly through the influence of their missionaries, and continued a constant war with the English during the turn of the century. The accounts of these struggles may be found in chapter three. As the early white settlers encroached on them, the Abenakis gradually withdrew to Quebec, Canada, and Vermont to protect the trade on Lake Champlain.

The Abenakis continued to migrate from Maine to Canada during the long wars that cost them their homes and land. The French welcomed them in Canada and provided village sites for them at Chaudière Rapids and Becancour. Some of them joined the Sokokis at St. Francis, Quebec, and with them carried out countless raids on the frontier settlements of New England. Outnumbered, the colony of New France would have fallen long before it did had it not been for their faithful Indian allies.

When the mission at the Chaudière Rapids was transferred to St. Francis during the 1700s, it caused the Sokokis to be greatly outnumbered by the Abenakis. In spite of this, the two tribes continued to hold their own identity. Each had its coat of arms and clan totem, the bear for the Abenakis and the turtle for the Sokokis.

Let us embellish on the clan totems and the tribal symbolism. The bear was called *Ogawinno*, or "the sleeper," because he passed the whole winter in hibernation. The turtle was called *Pelawinno*, "slow moving," because he took his time and enjoyed himself. These totems were often painted over the doors of the wigwams and tattooed on the tribe members' bodies. The Abenakis chose the bear for their insignia because they greatly admired that animal. They never tried to get a second shot at a bear because they believed it would cost them their lives.

No one really knows why the Sokokis had such respect for the turtle, but it was likely because of its slow movements. Nearly all Sokokis kept little turtles made of stone with their other possessions, and these are sometimes found today beneath the surface of their primitive campsites.

For many years, the Indians of St. Francis were divided into two parties named after the animals on their totems. In their councils, the tribal names were never mentioned. Their speakers instead said, "Oganwinno thinks in

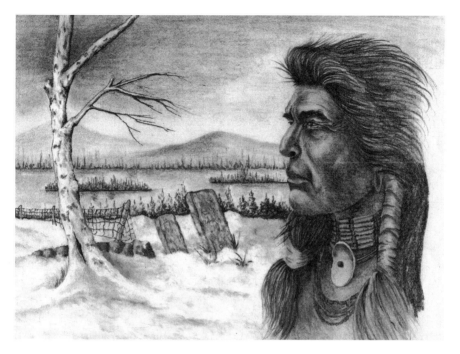

Abenaki Indian warrior overlooking Lake Winnipesaukee with Ossipee Mountain in the distance. *Courtesy of author.*

this manner" or "Pelawinno thinks in that manner." In playing such games as lacrosse, one team was called Ogawinnos and the other Pelawinnos.

In addition to the Sokokis of New Hampshire, the Nipmucs, Pacomtucks, Mohegans and Missiassiks were all represented at St. Francis to some extent and all spoke similar Algonguian dialects. The Abenakis accounted for over 75 percent of the population, and it was only a matter of time before the smaller groups became absorbed by the larger one. Today, the people and their language are known as Abenaki, and we seldom hear Sokokis mentioned except by students of Indian history or at Missisquoi in Vermont.

In 1960, the people of the St. Francis Reserve at Odanak celebrated the 300th anniversary of the founding of their village by the Sokokis of New Hampshire. Hundreds of their friends came from miles around to enjoy singing, dancing, feasting and participating in their religious services. This was considered a day of remembrance.

Culture and Customs

It was mentioned earlier that the Abenakis were a tribe of the Algonquian-speaking people of northeastern North America. They lived in the New England region of the country and in Quebec and the Maritimes of Canada. The Abenakis are one of the five members of the Wabanaki Confederacy. The confederation of Algonquian-speaking peoples inhabited New Hampshire before European settlement. By far the largest were the Pennacooks, located in the Merrimack River Valley near the present site of the capital city of Concord. These people of the Pennacook tribe lived in a fertile land, surrounded by cultivated fields.

Other groups of the Algonquian culture included the Sokokis north of the White Mountains, known as the Pigwackets, whose territory extended into western Maine in the upper Saco Valley in the Conways on the southeastern boarder of the White Mountains, and the Pocumtucks of western Massachusetts, whose territory extended into the lower Connecticut Valley of New Hampshire

Indian scholar Solon Colby states the following:

> *The Abenakis lived in bands of extended families and were considered extremely friendly. Hospitality was to them an unwritten law that would be obeyed and was part of their nature. Each man had different hunting territory inherited through his father, During the spring and summer months, bands came together at temporary villages near rivers and lakes, such as Lake Winnipesaukee at the Weirs.*

The bands were also found along the seacoast for planting and fishing and in the Cowass meadows in Haverhill, New Hampshire.

There was peace among the Native Americans and early European settlers. The native tribes taught the early settlers the essentials to their survival in the new countryside. Their villages held everything as common property, like a large family. Their homes were often sixty to eighty feet long with a round roof, which was generally covered with movable matting. The natives sought to trade with the settlers for metal tools and utensils, blankets and weapons, both for hunting and resisting attacks from their enemy, the Mohawks.

All the Abenaki tribes lived a lifestyle similar to the Algonquians of southern New England. They cultivated crops and located their villages near the fertile Pennacook land where fishing and hunting were plentiful. It was along the banks of the Merrimack and Connecticut Rivers in the rich soil that the Indians had their small patches of cultivated land where the women

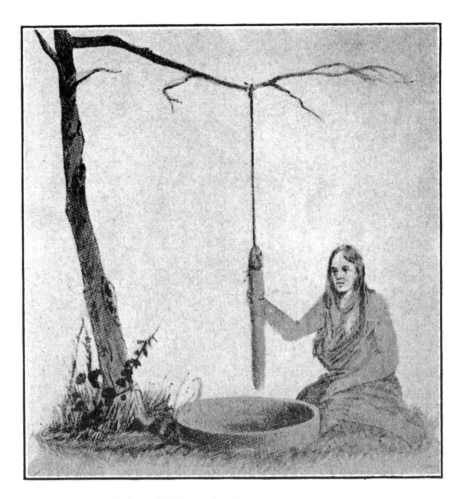

A typical primitive Indian mill. *Courtesy of author.*

planted corn, pumpkins, squash, melons and beans. They always ground the corn and cooked it into cakes or made mush.

When the corn was large enough, it was cut from the cob and boiled, which was known by the Indians as *samp*. When corn and beans were cooked together, the meal was called *succotash*. Their food was boiled in earthen pottery and placed on the fire. During the spring, the women tapped the maple trees and boiled the sap into a syrup in birch kettles.

They lived in scattered villages of families, and many villages had to be fortified, depending on the enemies of other tribes or Europeans near the village. Abenaki villages were quite small compared to those of the Iroquois.

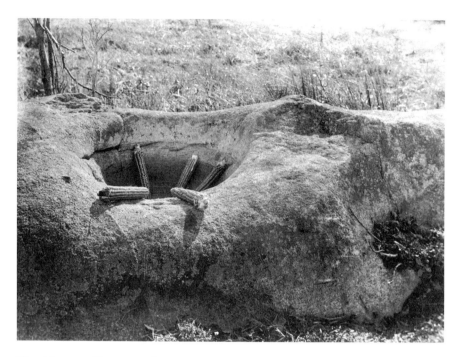

The old mortar. *Photo courtesy by Mary Burleigh.*

During the winter months, the Abenakis lived in small groups in dwellings of dome-shaped, bark-covered wigwams and a few oval-shaped longhouses. They would line the inside of their conical wigwams with bear skin for warmth.

The Abenakis were a farming people who supplemented their agriculture through hunting and fishing. Generally, the males were the hunters, while the women tended the fields and grew the crops. The New Hampshire natives conformed to the general pattern of the eastern woodland Indians. They lived in wigwams rudely constructed of bark and skins. Hunting was carried on by means of the bow and spear. Fish were taken in nets and spears at the Weirs.

The Abenaki people were considered a patriarchal society, which was common among New England tribes. However, they differed from the six Iroquois tribes in New York, and many other North American Indian tribes, who had matriarchal societies. In those societies, the women controlled property, and hereditary leadership was passed through the woman's line.

Entertainment

Indian historian and chief Donald Stevens describes the powwow celebration:

> *Entertainment and sports are considered very important to the Abenaki communities. Each year, many bands of Indians proudly have celebrations known as powwows. A good example is the Nulheganaki Powwow [at which there is] teaching, sharing and social activities while shedding any carnival aspects. These powwows are a means of celebrating with friends, tribe members and all Native Americans who value the customs and traditions of the Abenaki people. The gathering is meant to celebrate their culture and sovereignty, their way.*

Artisans present their talents, displaying dance, music, crafts and earthenware. Nulhegan chief Don Stevens always presents a warm welcome and honors the ceremonies, wampum history and craftsmanship.

The youth play games and are very active in sports. The boys were taught to run, jump and wrestle early, and even the small boys had skill with the bow and arrow. The older men took great delight in teaching the sports and games with the little ones, and they watched their improvement from day to day. While the boys were taught the art of warfare, the girls were given lessons in hard work. They would cook and maintain the domestic duties of the home.

Many things were taught to the youths and that would form their foundation for manhood and womanhood. Among them were the importance of hospitality, respect for the aged, truthfulness, honesty, independence and courtesy. It should be noted that most of the teaching of the young people was done by the grandparents, while the mother and fathers attended to everyday necessities.

The boys played games to win but were good-natured, no matter who the victor was. The girls enjoyed their dolls and mud pies and helping their mothers. The two pictures on the following page indicate the Abenaki children's pastimes.

Today, Indian brothers and sisters may still be found who proudly carry on the different traditions, such as the different dances and what those dances mean. It should be noted that during several of these dances there is no photography allowed, out of respect for the culture. Only four western Abenaki tribes are recognized today in the United States, and they are located in Vermont. The other western Abenaki tribes are located in Canada and New Hampshire.

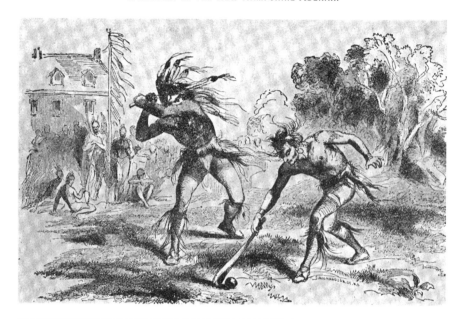

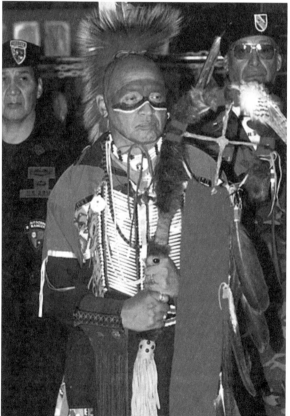

Above: Indian pastime. *Courtesy of author*.

Left: An Abenaki man celebrating a powwow in November 1998 in traditional clothing. *Photo by TheDrumPeople*.

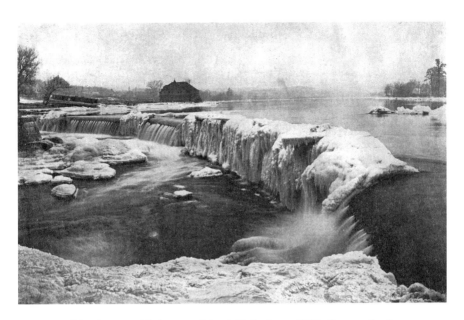

Amoskeag Falls, from an old photograph by A.H. Sanborn, 1906. *Courtesy of author.*

The voices of both the eastern and western Abenakis of New Hampshire shall be heard as they embrace and share their heritage and customs. These people shall remain as part of American culture, for they have indeed left a legacy to be cherished.

Religion

The religion of the people was considered animism, or the belief in spirits representing nature in its various phases. The name *manitou* was given to a spirit that might be good or evil, greater or lesser. The Abenakis believed in the immortality of the soul. Their principal deities were Kechi Niwaskw and Machi Niwaskw, which respectively represented good and evil. According to Maurault, they believed that the first man and woman ever created were made out of stone but that Kechi Niwaskw was not satisfied with them, so he destroyed them and created two more out of wood, from whom the Indians are descended.

The Abenakis were, however, most eager to receive instructions in the Catholic faith and showed a great desire to practice what they had learned about religion. Father James Bigot of the Chaudière Mission had never seen

any group of people that submitted to the Christian doctrines with more docility than the Abenakis.

According to Father Bigot, however, the Sokokis were quite different:

> *For the Sokokis, whose fickle nature I am acquainted with, and who are strongly inclined to drunkenness, I believe that I could not take any of them here without making a great choice and that our mission has not yet been established long enough in Christian piety to admit these people who might spoil everything. I had planned to make a quick visit to the Sokokis at St. Francis and the Algonquins at Three Rivers. I am already acquainted with most of them and I believe that the two or three short missions would accomplish a great deal. Perhaps the time will come for their conversion as it has for the conversion of the Abenakis.*

Historian John Josselyn, in his 1674 *Account of Two Voyages to New England*, reported the following version:

> *Ask them whither they go when they dye* [sic]*, they will tell you pointing with their finger to Heaven beyond the white mountains, and do hint at Noah's Floud, as may be conceived by a story they have received from Father to Son, time out of mind, that a great white agon their Country* [sic] *was drowned, and all the People and other Creatures in it, only one Powaw and his Webb foreseeing the Floud fled to the white mountains carrying a hare along with them and so escaped; after a while the Powaw sent the Hare away, who not returning emboldened* [them, and] *thereby they descended, and lived many years after, and had many children, from whom the Countrie* [sic] *was filled again with Indians.*

The Pemigewasset and Winnipesaukee Indians

New Hampshire was a network of pathways that followed the stream and rivers from lake to lake. Most famous was the trail from Canada to the Atlantic. From the villages of the St. Francis tribe north of Lake Champlain and Montreal, Canada, the trail down the Connecticut was a well-traveled route into Massachusetts and to the south.

Before the settlement of central New Hampshire, the Pemigewasset Indian tribe had a village near the junction of the Winnipesaukee and the

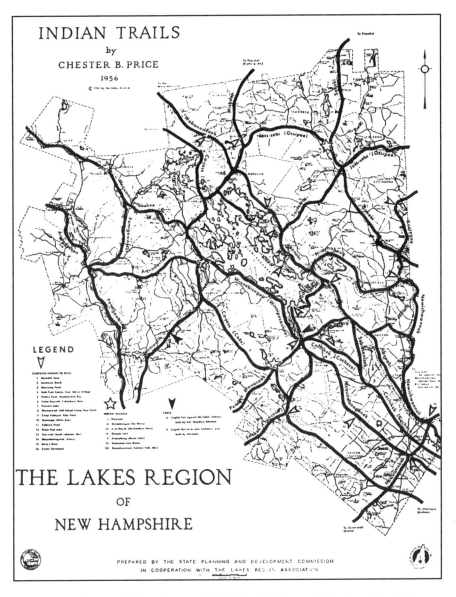

Indian trails by Chester B. Price. *Courtesy of Mildred Beach, Wolfeborough, New Hampshire, 1956.*

Pemigewasset Rivers. The Pemigewasset River carried the canoes almost to the Squam Lakes, over a divide by a short pathway into Lake Winnipesaukee and down the Cocheco River to the Piscataqua and the Atlantic Ocean. Today, the outlet from the big lake is by way of the Winnipesaukee River

connecting to the Pemigewasset River at the Franklin Fall, thus forming the Merrimack to the ocean.

The Pemigewasset trails joined at the town of Bristol with the Mascoma trail, which followed the Smith River in from Danbury and Lebanon. The Kancamagus trail joined the Pemigewasset trail at Woodstock, and the Asquamchumaukee trail joined it at the village site near the mouth of the Baker River just above Plymouth. The Pemigewasset River carried the canoes almost to Squam Lake, but they had to be carried by foot over the divide by a short pathway (the Indian Carry Path) into Lake Winnipesaukee and down the Cocheco River to the Piscataqua and the Atlantic Ocean. Another way into Maine from the Pemigewasset Valley was to cross the Ossipee Valley and go down the Saco River.

Before the Indian tribes became reduced in population by pestilence, nearly three thousand Indians lived along the banks of the Merrimack and its tributaries from the White Mountains to the Atlantic Ocean.

The Winnipesaukee tribe consisted of more than four hundred people with villages and campsites at Alton Bay, Melvin Village, Wolfeborough Falls, Moultonborough Neck, Lochmere, Laconia and the Weirs. Most of these Indians made their winter headquarters at the Weirs (Aquadoctan), where tons of smoked and dried fish were stored annually for winter consumption and where the hills at their backs protected their wigwam homes from the prevailing northwest winds.

The Indian villages were built in a protected location with wigwams of varying dimensions. Often there were several longhouses where inhabitants congregated. Smaller wigwams housed smaller related groups in a patriarchal manner.

In Solon B. Colby's *Indian History*, the author notes:

> *Aquadoctan was one of the largest Indian villages in New Hampshire and continued to be a permanent one until the spring of 1696 when the remaining families, with two young English prisoners, left their homes at Aquadoctan to join the Pequaket tribe on the Saco River near what is presently Fryeburg, Maine.*
>
> *The Weirs got its name from the fish traps maintained by the Indians in the wide shallow channel which form[ed] the outlet of the lake. Stones, which once held the uprights of the wooden fish-weirs in place showed the first settlers where the original Indian fishing-weirs were located, but the stones were used later in 1766 to make a wing dam for Ebenezer Smith's sawmill which had been constructed on the Gilmanton side of the channel the preceding autumn.*

This side of the channel is presently part of Laconia at the Aquadoctan Bridge at the Weirs. The village site extended along the north bank flanking the channel for more than a quarter of a mile. Beyond the Lakeport Railroad Station. Over ten thousand artifacts have been collected from the Weirs location and may be seen in Concord, Laconia, Manchester and Hanover.

INDIAN RELICS

Indian relics have been found in some quantities in New Hampshire. At least eight communities—Nashua, Manchester, Concord, Franklin, the Weirs, Hooksett, Suncook and Laconia—were built on the sites of Indian villages. One of the most interesting of these primitive villages was at the Weirs, where a large weir, or fish trap, in the shape of a *W* was built of stone and interwoven with saplings. It was here that the Aquadoctan tribe lived and fished at the channel outlet from Lake Winnipesaukee into Paugus Bay. It was thought that the Indians remained here until the 1700s. Another fishing village was at the division of the Merrimack into the Pemigewasset and Winnipesaukee Rivers. At this point, the shad went to Lake Winnipesaukee, and the salmon went up the cooler waters of the Pemigewasset. At this junction (Franklin Falls), many relics have been found and collected. The remains of an Indian fort at Little Bay in Sanbornton existed until well into the nineteenth century; it has been thought that this structure was built as a defense against the Mohawks sometime prior to 1675. Near Ossipee Lake, a large burial mound was discovered where skeletal remains were uncovered in a sitting position, grouped in circles. Skeleton remains have also been found at Brookline, Hudson, Dover, Sutton, Franklin, Keene and Claremont.

Most of the artifacts have included axes, knives, pestles, engraved stones, spearheads, arrowheads, gouges and chisels. Occasionally, pipes and pottery fragments have been dug up. The Lakes Region and the Merrimack Valley have been the most prolific sources of relics, especially the Weirs and Meredith Neck

Quebec Region: Site Cliché-Rancourt (BiEr-14)

The following essay was written and researched by Réjean OBomsawin, of the Abenakis Band of Odanak, Canada:

> The Eastern Townships region of Quebec has long been considered the most likely spot to have hosted the first human groups. However, in the early 2000s, despite numerous archaeological discoveries over the previous thirty years, no archaeological site attributed to occupation dating from the oldest Paleo-Indian period had yet been discovered on Québécois soil. Certain Québécois archaeologists even began to doubt that such sites would ever be discovered. The 1979 hypothesis of archaeologist Jim Wright, supported by archaeologist Chapdelaine in 1985, posting that such sites were to be discovered in the Eastern Townships of Quebec, due among other reasons to the proximity of that region to older known Paleo-Indian sites in Maine and Vermont, were thus subjected to criticism.
>
> The definitive proof was to be found on the Cliché-Rancourt (BiEr-14) site of Spider Lake in the month of August 2003 during a dig with University of Montreal Department of Anthropology. Students discovered the two first fluted points, or arrowheads, on Quebec soil. Because the objects were common to the early Paleo-Indian period, the discovery of these two fluted points came to confirm a human presence on Quebec soil from more than twelve thousand years ago. The Cliché-Rancourt site is currently the only site in Quebec on which a human presence of the early Paleo-Indian period has been demonstrated beyond doubt, although certain indicators suggest a possible early Paleo-Indian presence in the Squatec region and at the mouth of the Chaudière River. Because Spider Lake is located at the head of the Chaudière River, it is possible that the axis of the river may have at one time been a Paleo-Indian migration route.

Indian Government

The Abenaki government existed in New Hampshire for more than two thousand years before the first early European settlers came to New England. Even though tribal customs varied, their government was under the direction of a chief, for they were primarily patriarchal.

The chief elders were chosen for their wisdom and leadership ability. Generally, however, the Indian chief's authority was primarily advisory. A chief was a person who commanded respect. However, decisions on important issues were controlled by majority rule. Most importantly, a chief seldom acted without the approval and advice of his or her tribal bands.

The Abenakis lived under an inherited government of unwritten laws. A tribal council was composed of the senior men who had learned by experience the necessary regulations of the tribe. What these men said was tribal law. Each tribe had a leader, an office that was held by a man who either received his position by inheritance or was selected because of his authority in the time of crisis.

Punishment for disobeying the traditional laws of the tribe were often severe; banishment was often employed. The accused was compelled to run between parallel lines of braves, each armed with a club that aimed a blow upon his body. This type of tribal government was enforced according to customs and traditions that had been accepted by the tribe, using both shame and disgrace.

CHIEFS OF THE ABENAKI

Passaconaway

Several Indian chiefs left their impression upon New Hampshire's history and legend. The greatest leader was Passaconaway, head of the Penecook Confederacy when the Europeans came to our shores.

Passaconaway achieved a great reputation as a sorcerer, and in 1620, it was related that when the first settlers landed in Plymouth, Massachusetts, he called two or three powwows and spent the better part of three days in a swamp nearby invoking the wrath of a manituo on the early English invaders. When all his attempts to burn their vessel by lightning and destroy the settlement with magic failed, he sadly gave up and was convinced that the white man's magic was stronger than his own.

The colonists considered it providential that so powerful a chieftain should have been desirous of peace rather than war, never knowing about this attempt to get rid of them by sorcery. There was little doubt that if Passaconaway had marched against them with his five hundred warriors and allies, he could have swept the feeble settlement into the sea.

It was not long before the expanding English settlements came into contact with the Pennacooks, as this confederacy extended clear to the mouth of the Piscataqua to the Merrimack. So in 1629, Passaconaway ceded a large tract of land to them, which extended from the Piscataqua to the Merrimack Rivers, reserving only the fishing rights on the rivers for his people.

It is unfortunate to relate that Passaconaway and his people were repaid for their friendship with the English settlers with insults, robbery and mistreatment of various kinds.

In 1642, a rumor spread that the great chieftain was gathering his warriors for an onslaught on the settlements. This was entirely false, but orders were issued for his arrest. Passaconaway retreated into the dim wilderness of the White Hills until the excitement passed.

His only son, Wonnalancet, was not so fortunate. He was captured and led with a rope around his neck. The English then demanded his father deliver up all the arms of the tribe, but Passaconaway replied, "Tell the English when they restore my son and his squaw, I will talk to them." In spite of these insults from the settlers, Passaconaway held to his friendly policy with the English, although he grew to distrust their sincerity.

Passaconaway, however, allowed the Indian apostle Reverend John Eliot to convert him to Christianity, and it is said that he was a sincere believer and never wavered from his faith. He tried to persuade Eliot to settle among his people, but Eliot felt his duty called him to Natick.

There was little doubt that Passaconaway performed some marvels of magic. It is written that at one time, he had a bowl of water placed before him, and while he was droning an incantation over it, a black cloud gathered over the crowd. Then came a sharp clap of thunder, and to everybody's amazement, a solid piece of ice floated in the bowl in place of the water. This feat was performed during the middle of the summer. He was also repeatedly seen holding a venomous serpent in his hands as if it was a worm.

These magical abilities were described by an earlier unknown writer:

> He can make the water burn, the rocks move, the trees dance, metamorphosis [sic] himself into a flaming man. He will do more; for in winter, when there are no green leaves to be got, he will burn an old one to ashes, and putting these into water, produce a new green leaf, which you shall not only see, but substantially handle and carry away, and make of a dead snake's skin a living snake, both to be seen, felt and heard.

Passaconaway lived to a ripe old age, and in 1660, he made his farewell speech to his people, part of which follows:

> *I am an old oak that has withstood the storms of more than a hundred winters. My eyes are dim—my limbs totter—I soon must fall. But when young and sturdy, when no young man of the Pennacooks could bend my bow, when my arrows could pierce a deer at a hundred yards, when my arrows could bury my hatchet in a sapling to the eye, no lodge pole had so many scalps as Passaconaway's. Then I delighted in war. The English came and seized our lands. I made war on them—I tried sorcery against them—I who have communion with the Great Spirit dreaming and awake, am powerless against the Pale Faces. I have commanded with the Great Spirit. He whispers to me now. "Tell your people, Peace, Peace is the only hope of your race. I have given fire and thunder to the Pale Faces. I have made them [more] plenteous than the leaves of the forest and still they shall increase. Peace, Peace, with the white men," is the command of the Great Spirit, and the wish, the last wish of Passaconaway.*

Wonnalancet

Passaconaway was succeeded by his son, Wonnalancet, who was said to have been a very fine man of between fifty and sixty years of age when he became chief and who followed his father's advice and kept peace with the English. He was converted by Reverend Eliot, and during King Philip's War with the Bay Colony, when he found it impossible to restrain his people from taking sides with the Indians, he retired with most of his tribe to the upper waters of the Connecticut, to the land of the Coosucs, his kinsmen, where they hunted and fished until the war was over. About 1677, Wonnalancet moved to St. Francis, as the early settlers had taken over his corn land on the Merrimack so that he did not have enough grain to carry him through the winter, and shortly after, he died.

The brutality of the early settlers toward the Indians under Wonnalancet was almost beyond belief. At one time, they falsely accused him and his followers of planning to join in an uprising and sent a force to Penacook to destroy their wigwams and their winter's supply of fish. Wonnalancet had withdrawn his people to the woods and watched the destruction from a distance, but he sternly refused to allow his braves to fight. At another time, the Wamesits of Chelmsford, a branch of the Pennacooks had been so

mistreated that they presented a petition to the General Court pleading that they be removed from their reservation to a safer location. No attention was paid to this plea, and the Indians in desperation finally fled to the wilderness and the French, leaving behind them a few aged and blind kinsmen who could not accompany them. The Chelmsford men, when they discovered this, set the wigwam on fire and roasted the helpless remaining tribe members alive.

Kancamagus

His nephew Kancamagus succeeded Wonnalancet. He was a very able chief and for some time tried to retain the friendship of the colonists, but they were expanding rapidly now and were hungry for the Indian land. After suffering humiliation and ill treatment from the English, he yielded to the pleadings of his warriors and took up the war hatchet against the settlers. Before the break occurred, Governor Cranfield treacherously tried to induce the Mohawks, the Pennacooks' proverbial enemies, to take the warpath against them. Kancamagus, learning of the plot, gathered his braves and their allies, and in 1689, he descended like a thunderbolt on Cocheco, or Dover, killing and capturing fifty-two men, women and children. This, however, proved to be the death knell of the Pennacooks, for shortly after this, the remnants of this once powerful confederacy retired to St. Francis.

CHIEFS OF THE SOKOKIS

Squando

Historian Ernest E. Bisbee provides a brief excerpt history of the chiefs, which has been edited by the author.

The legend of the first chief of this tribe was Squando. He was tall with a large stature, dignified in his deportment, impressive in his address and strong of body and mind. The chief proclaims to his people the following:

> *With the wind, superstitions of the savage had become mingled. In his mind, the truths of Christianity was learned in the intercourse with the early white settlers. He aspired to the character of a prophet and made*

[his] followers believe that he held communication with the Great Spirits. [He claimed that] God, in the form of a tall man in dark clothes, had appeared to him, and commanded him to worship him more faithfully, to forbear hunting and laboring on the Sabbath, to abstain from drinking strong liquors, to pray, to attend the preaching of the gospel, and it had made known to him the entire extinction of the English by the Indians in a few years.

According to Squando, in 1675 came the fulfillment of his vision, and the solemn earnest chief wrought up the eastern Indians by revengeful eloquence to the highest pitch of excitement. It was also reported that young Indian children could "swim naturally, striking their paws under their throat like a dog, and not spreading their arms as we do." It is also recorded that some sailors, to prove the truth of the assertion, had overset the canoe in which Squando's wife and child were sailing. The child sank rapidly and was only saved by his mother, who, diving, brought the child up alive. Not long after, the child died, and his death was imputed to the treatment received.

This highly exasperated Squando, so he resolved to use his art and influence to arouse and inflame the Indians against the early settlers. How successful he was the annals of 1675–76 but too faithfully depict.

Author/historian Samuel Adams Drake, in his publication "The Heart of the White Mountains," closed his account of this chief with the following:

He was a great powwow, and acted in concert with Madokawando. These two are said to be, by them that knew them, a strange kind of moralized savage; grave and serious in their speech and carriage, and not without some show of a kind of religion, which no doubt, but they have learned from the prince of darkness.

Assacumbit

Of all the Sokoki chiefs, Assacumbit was possibly the most famous. Unlike Squando, he possessed no good qualities. To brutal courage he added a turpitude and ferocity unparalleled. An early historian by the name of Cotton Mather tells the story of a beautiful girl whom this chief had kidnapped from her parents: "The tears of this little captive provoked his wrath, and his daily practice was to whip the poor child until she could not stand." The story has it that "one day she had been beaten by him till he

supposed her dead, when she was kicked into the water and left. The poor child was rescued by a kind Indian, and returned afterwards to her parents." Mather says in conclusion:

> *This Assacumbit hath killed and taken in the war one hundred and fifty men, women and children.*
>
> *Not only did the chief become a deadly enemy of the British, but* [he] *incurred the intense hatred of the Indians by his arrogance and false pride. He was always seen carrying a large club, on which was notched, denoting the number of English he had killed. He was particularly attached to the French, and under some of their leaders won a great reputation. And so high did the French esteem their ally, that in 1705, he was sent to France. Here he was an object of great curiosity. At Versailles he was introduced to Louis XIV, surrounded by his splendid court. The King presented him with a beautiful sword, and the chieftain responded with the following remark as he held out his hand to receive it, "This had slain one hundred and forty of your majesty's enemies in New England." This so pleased the King that he knighted him, and commanded a pension of eight livres a day to be given him for life. On his return to America, he wore upon his breast the insignia of his knighthood displayed in large letters.*
>
> *Assacumbit was so exalted that he treated his men in the most arrogant manner, murdering one and stabbing another, which so exasperated those of their relations, that they sought revenge, but he fled for protection from the French. Still faithful to his former masters, he accomplished in the attack upon Haverhill.*

In this attack, Assacumbit performed with valor with the sword that had been presented him by the king of France. During the retreat, he was wounded in the foot.

John Greenleaf Whittier's poem "Pentucket" describes an Indian attack and later a Sokoki chief's burial:

> *Quiet and calm, without a fear*
> *Of danger darkly lurking near,*
> *The weary laborer left his plough,*
> *The milkmaid caroled by her cow;*
> *From cottage door and household hearth*
> *Rose songs of praise, or tones of mirth.*
> *At length the murmur died away,*
> *And silence on that village lay…*

A yell, the dead might wake to hear,
Swelling on the night air, far and clear;
Then smote the Indian tomahawk
On crashing door and shattering lock;
Then rang the rifle-shot—and then
The shrill death-scream of stricken men;
Sunk the red axe in women's brain,
And childhood's cry arose in vain.
Bursting through roof and window came
Red, fast, and fierce, the kindled flame;
And blended fire and moonlight glared
Over dead corpse and weapons bared.

STEPHEN LAURENT

Hereditary Chief of the Abenaki Indians

Stephen Laurent was the son of Chief Joseph Laurent, chief of the Indian village at Odanak on the St. Francis River in Quebec, Canada. Stephen was born in 1909 in the village of St. Francis. These reservation Indians spoke French in school. At the age of fifteen, he went to Nicolet Academy and college in Nicolet, Quebec. His father, Joseph Laurent, was a student of Indian culture and language and wrote the authoritative *Abenakis and English Dialogues*, which contains, among other things, an etymology of Abenaki names.

During the summer months, Stephen's father led a group of his people back to the old hunting grounds at Intervale, New Hampshire, where they sold Indian wares and spoke English with the tourists. He made these trips for many years. During these annual visits, he met many renowned scholars seeking conversation with Chief Laurent. A bronze tablet now exists there commemorating his father, Joseph Laurent.

In September 1952, Stephen married Margaret Pfister, a New York high school teacher of English and French. Margaret had been a summer resident of Intervale. After marriage, they lived in Intervale in a quiet home on the hillside off Route 16, just north of the Intervale railroad station. They operated the Indian Shop, where he continued to meet Indian lore probers.

I visited Stephen at his lovely home on Sunday, January 24, 1999, in Intervale, New Hampshire, and promptly bought a signed copy of his

father's French-Abenaki dictionary, published by Chisholm Bros. Publishers in Portland, Maine.

During my visit with Chief Laurent, then celebrating his ninetieth year, I enjoyed a most fascinating conversation on the Indian language. Chief Laurent commenced to relate the following:

> *Our American Indian languages were never written. When the last speaker of one of these languages dies, that society's thought systems and expressive strength are gone. This work* [the dictionary] *attempts to save something substantial of the Abenaki language for future students to understand a bit of human history.*
>
> *Many Indian words appear to contain several elements, so altogether may be more of sentence. Any word may indicate the tense and grammatical understanding of the verb as well as the gender and number of subjects. Such words often express subtleties that our expressions gloss over, or at least require additional statements.*
>
> *Like all North American Indian languages, the Abenaki dialect belongs to the group called "holophrastic," from a Greek compound meaning that a phrase or entire sentence or description is telescoped into a single word. The Indian mind delights in synthesis and compresses into one word both object and action, with all that modifies either objects or action.*
>
> *The Abenaki Indians, like the rest of mankind, consider their own race to be the cream of the crop. The belief was further strengthened by their theory of the creation of man. This is how it went. First, the Great Spirit made the white man and found him too white. Next, he decided to make a black man; so he made the* [black] *race. Finally, he thought he would try making a man neither wholly white nor completely black, so he made his masterpiece, the American Indian, correcting in this last creation the various imperfections, which he had found in the two previous models.*
>
> *The Indians had their folklore and superstition, which made a bridge between religion and medicine, as we see in the institution of shamanism. The shaman, or "medicine man," combined the function of priest and soothsayer and physician. As an example of the former of these functions, we have the following story, which also explains the origin of a place-name.*
>
> *It seems that once, the Iroquois attacked the Abaneki village when all the warriors were absent and, of course, killed most of the old Indians, women and children. Upon their return to the village, the Abenaki warriors took stock of the situation, held a council and decided to lay their case in the hands of* [the] *Shaman and abide by his decision. After many incantations,*

adjurations and magical songs, he said to those listening outside his magic tent, "I see our enemies. They are on a small island. We will go after them immediately, and not one of them will escape."

They arrived in the evening at the little island occupied by Iroquois. And we are told that two Abenakis, Beaver and Muskrat, dived to the shore of the island. They remained submerged, while the Iroquois were in the process of eating. And the chief said, "I am going to hit an Abenaki." And he hurled a big shinbone toward the shore. And behold, it hit Muskrat right on the head. Immediately, Beaver ducked his friend's head under the water so as not to attract attention.

As soon as the Iroquois were all asleep, they punctured all their canoes and then dove back to his friends. At once the Abenakis got ready, but they crossed very cautiously at dawn.

After they had surrounded the Iroquois, immediately they began to fight; they shouted the war cry and killed all the Iroquois. They stuck on poles all the heads of the Iroquois, and these they planted all around the little island. Ever since this island has been called "Head's Island."

This incident explains why one of the islands north of Grand Isle in Lake Champlain appears on the old maps as Head's Island, or, in French, Île aux Têtes.

My Sunday afternoon was very well spent with Chief Laurent. His French-Abenaki dictionary is most interesting and holds a prominent place in my library.

Stephen Laurent followed his father in trying to keep alive the culture and language of the Abnekis. In doing so, he translated Farther Rasle's *French-Abenaki Dictionary* into English and immediately continued to write another French-Indian dictionary.

On May 27, 2001, Chief Laurent died at the memorial Hospital in North Conway at the age of ninety-two.

Chapter 2

LANGUAGE OF THE
NEW HAMPSHIRE INDIANS

The native peoples of New Hampshire did not have a written language; however, pictorial graphics were used. Important knowledge was memorized and passed down from one generation to another. This would include their laws and rules of behavior. The Abenakis are a tribe of Native American and the First Nations people, as well as one of the Algonquian-speaking people of northeastern North America. The Abenakis live in the New England region of the United States and Quebec and the Maritimes of Canada, a region called *Wabanaki*, or "Dawn Land," in the Eastern Algonquian languages. The French, however, called the western Abenaki the Sokokis, borrowing the name of the southern New England Algonquian for Abenaki.

The language of the Abenakis was exclusively an oral language, not a written one, so there has been much disagreement among scholars not only concerning the spelling but also about the meaning of various Abenaki words. The word *Abenaki* is a linguistic and geographic grouping and means "a strong central power."

Mary A. Proctor, author of *The Indians of the Winnipesaukee and Pemigewasset Valleys*, states the following:

> *We need not accept the theory that the people of Asia were descendants of the race which once inhabited this American continent of ours, though recent discoveries in Central America, especially in Yucatan, go far to prove*

AREAS OF KNOWN INDIAN ACTIVITY IN NEW HAMPSHIRE
(No numerical validity is implied.)

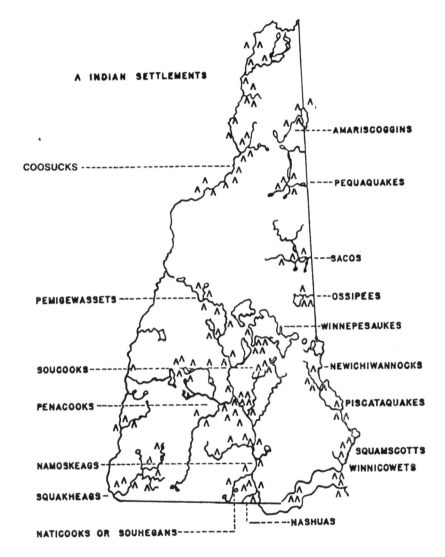

Map of Indian settlements by tribes. *Courtesy of the author.*

it. It is however, easy to believe that this country at the south of us was the ancient home of the mount-builders, and of the cliff-dwellers; also of the wandering tribes of red men who once lived here.

Records show that numerous tribes inhabited New Hampshire, divided into several minor tribes, the different tribes located at different areas and under their own chiefs. Thus having no written language, their vocabulary was as varied as the tribes themselves.

Fortunately, early missionaries who devoted their lives to the service of the natives have left us with a list of words and some definitions from which it is possible to get to the meaning of their language. Reverend John Eliot, in his translation of the Bible, gives us much of the language of the Massachusetts Indians with whom he worked. Roger Williams furnished us with some translation to the Narragansett language in the Rhode Island area.

However, words given by the English to the Massachusetts and Rhode Island natives were as different from those given by the French to those of Maine and Acadia (the land of the Abenakis).

The Native Americans who inhabited Maine and Acadia and extended across New Hampshire gave names to most of our mountains, lakes and rivers, and their language was written by the French missionaries. Consequently, when we attempt to interpret these names according to the English spelling, much confusion results. Because of this complicated translation, we have failed to preserve the true meaning of those localities bearing the names given by the Abenakis.

It was Father Rale, a Jesuit missionary to the Indians at Norridgwock, Maine, who became familiar with several native dialects and understood the language as well as he did French and English. It was only by the most persistent effort that he accomplished the feat. During the years that he was learning the Indian language, he spent part of each year in their homes to acquire firsthand the peculiarities of their speech. The knowledge of their language gave him an advantage that few other teachers or missionaries possessed.

Unfortunately, at this time, there were frequent hostile outbreaks between the early settlers of New England and New France, and in 1724, there was a massacre at Norridgewock in which Father Rale was killed. It was one of those tragedies of the eighteenth century that was so bloody, a monument was erected on the spot where he was killed. He did, however, provide us with an Abenaki dictionary.

THE FIRST LANGUAGE OF NEW HAMPSHIRE

Stephen Laurent, authority on the language of his people, student of Indianology and often called the "hereditary chieftain of the Abenakis," has to this day preserved the Abenaki language of New Hampshire as spoken by the Native Americans themselves. Chief Laurent has provided the following insight to the Abenaki language as it was spoken in New Hampshire:

When the white settlers first stepped foot on New Hampshire shores and greeted the Abenakis, [they] heard a language "so soft and fluttery it would not disturb the birds"—the soft-spoken dialect that has for many years plagued intrigued scholars and missionaries with its intricacies.

The naturalist Thoreau perhaps found the tongue a little more baffling to master than he had been led to hope by his Abenaki guide, Joe Polis. In his memoirs, he records, "I observed that I should like to do good to school him to learn his language, living on the Indian island the while; could this be done?"

"Oh yes," he replied, "good many do so."

"I asked how long he thought it would take. He said one week. I told him that in this voyage, I would tell him all I knew, to which he readily agreed."

Of course we have no record of Thoreau's progress. But we do know that the Reverend John Eliot, who translated the Bible into Abenaki, confessed his inadequate mastery of the tongue after twenty-five years of intensive study. And Paul Le Jeune, scholarly Jesuit missionary, acknowledged that it would take a lifetime to achieve conversational fluency. Meanwhile, he was reduced to making himself understood by jabbering and gesticulating. The following is recorded:

For their own understanding and needs, their language was adequate, flexible, and elastic. However, for the white man striving to learn the language, this very elasticity became the source of some of his major difficulties. Laying hold on a word was a little like trying to grasp a wiggling ell. Even the simple word "hand" gave one missionary a great deal of trouble. The Jesuit, pointed to his own hand, looked inquiringly at the Indian. The latter grunted, "Kelji," i.e., "Your hand." Later, to verify this record, he repeated his question, pointing to the Indian's hand. This time the answer was "Nelji," i.e., "My hand." In a final attempt to isolate the simple word for just the word "hand" itself, detached from personal possession,

he devised the following stratagem: he bade someone inside a wigwam to stretch forth his hand through a slit in the curtain of the doorway. Far from being simple, the reply became more complex. It was, "Awamelji," meaning "somebody's hand."

In general, two stumbling blocks lay in the path of the missionary's approach to linguistic proficiency. One, the reluctance of the prospective convert to serve as his teacher, and two, the inability of the primitive instructor to furnish him with the exact equivalents.

The first could be circumvented in some degree by the periodic offering of tobacco. To quote LeJeune: "I must ask twenty questions to have the meaning of one word, so little inclined is my teacher to give instruction, and at every new difficulty, I must give him a piece of tobacco to gain is attention."

The second problem was well-nigh insuperable because of the absence of abstract terms in the language. The Indian tongue was rich in concrete differentiations. They had a name of the observation, and their observation was extensive and acute. So there was sometimes [a] confusing plethora of words for items peculiar to their life. For "moose," they had no fewer than six words, according to whether it was a male or a cow moose, a yearling male or female, a two-year-old, etc. But their words could not be applied figuratively or symbolically. It was contrary to Indian mentality to use the word "bread" generically to signify "food." So, even such [a] simple-seeming task as translating the petition for "daily bread" in the Lord's Prayer presented difficulty. "Abon" was the Abenaki word chosen as the nearest equivalent of the English word "bread." This however, turned out as not too happy a choice since it inferred [sic] to insipid little corncakes baked in ashes—the daily fare for every Indian. Small wonder that the Abenaki could work up scant enthusiasm for a prayer demanding an item so readily come by. As one squaw expressed it, "If we ask for anything at all, let it be for something worthwhile. Besides, if God gives us bread, who will give us the meat and fish?"

As an unwritten dialect, Abenaki led some of the early writers to believe that the language was crude and entirely lacking in rules of grammatical structure. However, a study of verbs alone reveals a high degree of inflectional complexity. It is because of this verbal richness that philologist have called the Indian language a language of verbs.

While there is no gender, the Abenaki dialect fully compensates for this by the division of nouns into two categories: noble and ignoble. Generally

speaking, living things were of the noble category, while inanimate objects belonged to the ignoble class, with a few exceptions. A tree was considered of the noble class while standing, but it was ignoble when felled.

For superstitious reasons, certain diseases deemed unaccountable by the shaman or medicine man were placed in the noble category. Probably it was feared that placing the name of these illnesses in the ignoble group might bring retaliatory measures on the part of the "Evil Spirit," a spirit that loomed large in the consciousness of the Abnekis. Objects held indispensable, or in high esteem, such as snowshoes or tobacco, also demanded the noble inflectional endings.

Amazingly, even with this complexity and without written or verbal instruction, the Indians managed to speak their language with grammatical correctness. It would have been a flagrant error for one to give a noble word an ignoble ending, as it would be for an Englishman to say, "The queen has just put on his crown."

REVEREND JOHN ELIOT: MISSIONARY

Earlier, the name John Eliot and the impact he had on the religious evangelism of some of the great leaders of the Abenaki tribes was mentioned. John Eliot immigrated to Boston as a chaplain on the ship *Lyon* and arrived in 1631. An important part of his ministry was focused on the Native Americans. He became known as the "Apostle to the Indians." His great work was the translation of the Bible into the language of the New England Indians in Massachusetts and the Abenakis of New Hampshire. The task was completed in 1658 and was published between 1661 and 1663.

As a missionary, John Eliot encouraged the natives to create a Christian society. During his visits to New Hampshire, his Christian teaching influenced many of the chiefs and Indian tribes; however, much of his missionary work was focused in the commonwealth of Massachusetts.

John Eliot was an intrepid traveler. The Indians had faith in his confidence in them. However, John Eliot's fine work was sadly interrupted by the rise to power of the Indian chief King Philip. John Eliot was a major force in the peace movement between the Abenaki tribes and the English.

Reverend Eliot died in 1660 at the age of eighty-five. His last words were "Welcome joy!" Cotton Mather called John Eliot's missionary career the epitome of the ideals of New England Puritanism. According to historian

John Carpenter, William Carey considered Eliot as a canonized hero in his groundbreaking "An Enquiry into the Obligation of Christians to Use Means for the Conversion of the Heathen," written in 1792.

Early History of St. Francis X (1636–1673)

It has been recorded in the Jesuit relations of New France that in 1642, when the French first celebrated the Feast of the Assumption at Montreal, a few Algonquin Indians assisted at the solemnity. After the feast, many of the French traveled up to the summit of the mountain, accompanied by Indians. From the summit, one of the Indians pointed at the countryside to the south and east and said to the French:

> *There is where heavily populated Indian villages were located at one time. The Hurons, who were our enemies at the time, drove our ancestors out of that country. Some of them withdrew towards the country of the Abenakis, others went with the Iroquois and many of them surrendered to the Hurons who adopted them into their tribe. This is how that country came to be deserted.*

This story of 1642 was an ancient one, which was confirmed by older Indians whose ancestors had once lived in the area. In 1635, the Company of the Hundred Associates granted nine thousand square miles of this uninhabited wilderness to François de Lauzon.

Before becoming the property of Jean Crevier in 1673, the Manor of Saint Francis belonged to the Lauzon family in 1635 and then to Pierre Boucher in 1662. Originally, this property was included in the Manor of Citière, granted to François de Lauzon on January 15, 1635. Jean de Lauzon, manager of the Company of the Hundred Associates, had obtained land from the company for his son François, a vast spread of land that the governor of Canada was asked to have marked out. Three years later, on July 29, 1638, Monsieur de Montmagny took off the restrictions of the property and named it the Manor of Citière, following the wish of young François, who took possession of it through his attorney Nicolas Trevet. The property extended on the south side of the St. Lawrence from the St. Francis River to the Ste. Marie (Chateauguay) River, to have a frontage of 60 miles and a depth of 150 miles. This large grant of 9,000 square miles was later cut up into the grants of Laprairie, Longueuel, the

island of St. Paul, St. Helena and Rhode, as well as that of St. Francis. The remainder of the land, being uninhabited, was put back into the public domain between 1665 and 1672 as the king of France had abolished the Company of One Hundred Associates in 1664 and had taken back the land that had been previously granted but not yet settled.

Pierre Boucher never occupied the land, and on July 23, 1673, he sold the northern part of the concession to his brother-in-law, Jean Crevier. About the same time, he ceded to Michel Le Neuf the southern part called Yamaska.

Jean Crevier, the son of Christiphe Crevier and Jeanne Enard, was baptized at Three Rivers on April 3, 1642. In November 1663, he married Margarite Hertel. This was the first marriage of a boy and girl who were both born in Three Rivers. He engaged in trade with the Indians, and as mentioned earlier, he exchanged powder, lead, guns, blankets and fire water for their furs. By 1673, it was recorded that he had accumulated enough to purchase the northern part of Pierre Boucher's (his brother-in-law) concession and had erected a manor of modest size. Without doubt, it was Jean Crevier who induced Sokoki Indians from New Hampshire to settle down near his trading post on the St. Francis River.

The historians of the Odanak Village in Quebec, Canada, give the following account:

> *Marguerite Hertel, owner of the St-Francis seigneury, ceded some of her land as a refuge for displaced Native Americans, and the villages of St-François and Becancour in Quebec eventually became the scene of the reconstitution of Abenaki life under the severe tutelage of Jesuits who demanded more cultural assimilation here than they had on the Kennebec. Abenakis were not entirely safe even here; Odanak was destroyed by the British in 1759, apparently in retaliation for the Abenaki long alliance with the French.*

Odanak Village

During the French and Indians Wars, the shortest route to the Indian village of St. Francis, now called Odanak Village, was by way of Lake Champlain and the Richelieu River. If traveling conditions were favorable, it usually took about fourteen days to get from Penacook to St. Francis.

The village is pleasantly situated on the high east bank of the river, about six miles from its junction with the St. Lawrence. Today, about 130 Indians may be found at St. Francis, but the band numbers over 500 members. There is, in addition, a number of residents of St. Francis descent who have given up formal connections with the band and live in other parts of Quebec, Ontario and the northeastern United States, often not known as Indians by their neighbors. The remaining Indians who are versed in their original language are very few of the elderly residents.

From this village came the war parties that raided the New England frontier and warriors who ambushed Braddock. From it came Hannah Dustin's captors and the attackers of Fort No. 4, now Charlestown, New Hampshire. This is the village where John Stark was held captive. Further discussion of these events will be covered in chapter three, "Indian Warfare."

The reservation of Odanak has an excellent museum. It is worthwhile to visit its exhibits and explore the Abenaki culture.

The Nulhegan Band of Coosuk

Abenaki Nation

The Nulhegan tribe, the Memphremagog band and the Northern Cowasuk band give the following history:

> They lived here, in the St. Francis, Nulhegan, Memphremagog, Passumpsic, and Upper Connecticut Basin of Vermont, northern New Hampshire, and the Eastern Townships of Quebec, from time beyond memory. Our memories and oral history tell about when the old ones were faced with the decision to stay or travel west to the Great Lakes. Some made the journey and some stayed here in N'dakinna [our land]. Our oral history tells of the wars and hardships of survival and acceptance in the centuries after.
>
> Our presence here has not always been wanted, warranted, or even admitted. Memories and stories of eugenics and ethnic cleansing in the 19th and 20th centuries brought animosity and distrust that still manifests itself today.

Chief Donald Stevens of the Abenaki Nation, and the Nulhegan-Memphremagog band of the Coosuk today, gives the following account:

The Nulhegan Abenaki Tribe is serious about achieving economic self-sufficiency and stability for our people, which means controlling our own destinies. With energy, determination, vision and a commitment to the larger community, our sights are set upon utilizing our own resources and abilities to grow in the realm of economic development, more specifically, cottage industry and cultural tourism.

The revitalization, preservation and protection of our cultural, historic and physical values and resources are the foundation upon which we stand.

Teaching our young ones the skills and customs of our ancestors keeps our heritage alive. We empower our children not only to survive but also to thrive during economic hardships by utilizing the traditions and practices of our ancestors, such as organic agriculture and permaculture.

Coos

Pine Tree

The Coos is the name of the most northern county, which was derived from the Indian tribe living along the valley of the Connecticut River, especially at the so-called Ox-bows or bend of the river at Lancaster and Haverhill where the natural meadows and flood plains provided fields for raising corn. *Coas* or *cohas* was a pine tree. Formerly the name was spelled with the extra letter, *cohos* or *coohos*.

Nashua Matukko

Land Between

The settlement of Nashua is located in southern New Hampshire and lies along the Merrimack and Nashua Rivers. It was settled by the English in 1656 and was chartered in 1673 as Dunstable.

It was originally part of Massachusetts until a boundary settlement in 1741 placed Nashua in New Hampshire. In 1803, the village of Indian Head, across the Nashua River, took the name of Nashua (possibly derived from the local Indian tribe).

OSSIPEE

Pine Tree Lake

The name Ossipee was referred to as "Wigwam Village" and later "New Garden." This town bears the name of the Indians who live in this area east of Lake Winnipesaukee. It was once the site of an Indian stockade fort, designed to protect the tribe from attacks by the Mohawks from the west. Early in 1725, the Indian stockade was destroyed and then rebuilt by Captain John Lovewell of Dunstable. Later that year, Captain Lovewell led a small band of men to attack the Indians at Pequawket (now Fryeburg, Maine). Captain Lovewell did not survive the attack, but the battle was memorialized in the anonymously written "Ballad of Lovewell's Fight" and was the subject of Henry Wadsworth Longfellow's first published poem, written when he was thirteen years old.

THE PEMIGEWASSET AND WINNIPESAUKEE INDIANS

A Swift and Rapid Current and the Beautiful Water in a High Place

During the past six years, many visitors to the Granite State have asked me about the early Native Americans who resided in central New Hampshire. The best way to impart this interesting history is to present Solon B. Colby's fascinating articles on the said tribes from his *Indian History:*

> *Previous to the settlement of Central New Hampshire, the Pemigewasset Indians had a village near the junction of the Winnipesaukee and Pemigewasset Rivers. The site of their village was made into a public park in 1900, and during that process, hundreds of artifacts were discovered, some of which resemble those used by the so-called Red Paint People of older times. The Proctor Collection, which contains several hundred specimens from the Franklin-Tilton area. This is the same location as mentioned earlier, and may be seen at the Dartmouth College Museum in Hanover, New Hampshire.*

On the north side of the highway, on Willow Hill in Franklin, as illustrated earlier in chapter one, there is a glacial boulder with a large bowl-like depression

that the Indians used as a mortar in which to pulverize their corn. The first white settlers also used this primitive mill when meal was needed. Pestles of stone or hard wood were used in conjunction with mortars. Heavy pestles were usually suspended from a limp, which made the work much easier for the squaws.

As their numbers were diminished by smallpox, they moved upriver to the intervales above Plymouth where there had been a village many years ago. They were still known as the Pemigewasset tribe because their headquarters were still on that river. Abbe Maurault, in his *Histoire des Abenakis*, calls it the "Riviere à la Graisse D'Ours" (Bear's Grease River).

Musgrove's *History of the Town of Bristol* mentions the many artifacts found at Newfound Lake near Whittemore's point and Fowler's River. The dam at the outlet of the lake raised the water level enough to cover practically all of their lakeside campsites. One of their favorite campsites was at Profile Falls on the Smith River, and another was at the spring near the old highway from Bristol to Hill, New Hampshire.

The Pemigewasset and Pass-aqua-nik trails joined at Bristol with the Mascoma trail, which followed the Smith River in from Danbury and Lebanon, New Hampshire. The Kancamagus trail joined the Pemigewasset trail at Woodstock, and the Asquamchumaukee trail joined it at the Pemigewasset's old village site near the mouth of the Baker River, just above Plymouth, New Hampshire.

In October 1743, an Indian named Coaus came to a council held in Portsmouth and petitioned the governor to place a truck house or trading post near Pemigewasset, where they might have such supplies as was necessary for their furs and that they might not be imposed on as they often were when they came into the lower towns. They also thought it reasonable to have some satisfaction for the lands if the English settled it, they never having had any as yet.

The governor asked him if, for the present, orders should be given to some suitable person at Canterbury to supply them; it would answer their end. To this, he answered it would do very well.

The governor asked, "How many Indians are there?"

The Indian replied, "There are but three or four that claim the lands at Pemigewasset."

The governor asked what things would be most suitable.

"Powder, shot, bullets, flints, knives, blankets, shirts, cloth for stockings, pipes, tobacco and rum," Coaus replied.

On being asked how many would come down, Coaus said there would be fifteen and that they would come in the spring when the snow was gone. If

the governor would send them word at Canterbury, they would give notice to the rest of the Indians and come at the time the governor requested. The governor told Coaus that the matter of a truck house would be brought up at the next meeting of the assembly.

The House of Representatives met on Thursday, October 29, in answer to the written message brought that day by the secretary about appointing a truck master to trade with the Indians. The House unanimously came to this resolution: "That if they can have no voice in appointing a Truck Master they will not make any supply for that trade. Sent up by His Excellency's Message on file."

On the fertile intervales by Livermore Falls and at the junction of Baker's River and the Pemigewasset, the early settlers found the hills and ridges of old corn fields and the ashes of old campfires with arrowheads, stone mortars and pestles and other implements. Priest Fowle found many traces of the ancient inhabitants on his land bordering Squam Lake. A French sword, a relic of the frontier wars, was dug up in Holderness Village many years ago.

Black bears have always been numerous in the Pemigewasset Valley. Thomas Locke, an early settler living near Danforth Brook in the town of Bristol from 1777 to 1782, killed sixteen bears on Briar Hill. The prevailing growths of oak and beech trees produced tons of acorns and beechnuts, which attracted bears, deer, raccoons and passenger pigeons. Indians from

Pemigewasset Valley from Parker's Ledge in North Woodstock, New Hampshire, circa 1946. *Courtesy of the author.*

Coos, Ossipee, Penacook and Winnipesaukee came to hunt with the friendly Pemigewassets, who welcomed them with feasting and rollicking by young and old.

Before the Indian tribes became reduced in numbers by pestilence and migration, nearly three thousand Indians lived along the banks of the Merrimack and its tributaries, from the White Mountains to the Atlantic, a distance of about two hundred miles. By 1674, according to Major General Daniel Gookin in his *Historical Collections of the Indians*, "There are not of this people left at this day three hundred men besides women and children."

In 1614, sixty years previous to Gookin's notation, the Winnipesaukee tribe alone consisted of more than four hundred people with villages and campsites at Alton Bay, Melvin Village, Wolfeboro Falls, Moultonboro Neck, Lochmere, Laconia and the Weirs. There are few, if any, islands in the lake that have not produced considerable evidence of aboriginal occupation.

Aquadoctan was one of the largest Indian villages in New Hampshire and continued to be a permanent one until the spring of 1696, when the few remaining families, with two young English prisoners, left their homes at Aquadoctan to join the Pequaket tribe on the Saco River near what is now Fryeburg, Maine.

The Indian village site extended along the north bank of the channel, flanking it for more than a quarter of a mile and along the lakefront a quarter of a mile beyond the railroad station. The total length of the site was more than a half mile, but it wasn't all occupied at one time. The land on the south side of the channel rose abruptly and was too steep for wigwam sites, but many artifacts have been found on that site above the bridge where the land is flat.

Over ten thousand artifacts have been collected from the Weirs area alone, and they may be viewed in collection at Concord, Manchester, Hanover and Laconia, New Hampshire, as well as in the Peabody Museums in Salem and Cambridge, Massachusetts.

During farming operations on the north side of the channel, large numbers of stone tools were recovered. When the cellar for Moore's hotel was dug about 1890, workmen found forty or fifty gouges, celts and spearheads. They also found a clay pot containing about three quarts of red ochre. The pot was crudely made without decorative markings and resembled a style of pottery known as Early Woodland.

When the land for the open-air theater at the Weirs was leveled off with a bulldozer, numerous artifacts and several burials were uncovered. The skeletons were little more than white streaks of calcium in the soil.

Projectile points with bifurcated bases have been found at the Weirs and Fish Cove. Fluted points will undoubtedly be discovered in the Lakes Region as interest in New Hampshire archaeology continues to increase.

The pottery in this area is mostly grit tempered and resembles that found in other parts of the state, but not in such large quantities as have been found at Amoskeag Bluff (Smyth Estate) in Manchester, New Hampshire.

Winnipesaukee is derived from *Wiwininebesaki*, an Indian word that means "the lake in the vicinity of which there are other lakes and ponds," or perhaps a still better translation would be "the Lakes Region."

The Weirs was known to the Indians for miles around as a great fishing place, and they had several names for it, among which were *Ahquedaukee*, *Aquadoctan* and *Aquedaukenash*, all of which mean weir or weirs.

Jacob Eaton started to build on Hilliard Road, near Pickerel Cove, in 1765. By September 29, 1766, he had built a house, cleared three acres of land and felled the trees on six additional acres. On the lot where Eaton built were several apple trees that Indians had set out many years before. These, so far as we know, were the only apple trees ever found on Indian lands in New Hampshire. It was here that the first white child of Meredith was born on March 11, 1767. The little girl was named Thamor Eaton.

Asquamchumauke

Place of High Water

In the spring of 1712, Lieutenant Thomas Baker came upon the Connecticut River and crossed at what is now known as Haverhill, New Hampshire. He followed the Asquamchumauke from Warren down to Plymouth and found Indian chief Waternomee camped where the Asquamchumauke joins the Pemigewasset River. He was shot by the chief and buried by some of his own party, some of whom escaped. This is the reason Asquamchumauke River is now shown on the map as the Baker River.

In 1752, John Stark, his brother William, Amos Eastman and David Stinson came through what is presently known as Plymouth, New Hampshire, looking for a good place to trap. They turned off the Asquanchumauke River at Rumney and followed a little brook from Stinson Lake. In a few days, they saw a party of Indians, so they decided to leave at once. They put their furs together and got in the canoes to escape. Stark lay down in the

bottom of the canoe, and the current carried him downstream, saving his life after the other three were killed. He returned to Deerfield to tell the tale and named the lake and the mountain for his friend Stinson.

Along the Aquamchumauke's crooked banks, a blazed trail led over the divide to the Connecticut River and on to Canada by Passumpsic Valley and Lake Mamphremagog. Countless Indians traversed this trail on their way to the Weirs on Lake Winnipesaukee where shad was caught.

On a spring morning, squaws were planting maize in the meadow near the Pemigewasset, papooses were playing about, the old men and women were basking in the warm sun and the young men were away hunting.

Suddenly, musket shots rang out. Squaws and children fell as they ran to find one another. One or two escaped and ran for help. Realizing large numbers would soon be upon them, the attacking party fled, taking as many valuable furs as each could carry.

PENACOOK

Winding and Broad Quiet Place in a River

According to the Penacook historical records, the Pennacooks, also known by the names Merrimack and Pawtucket, were "a North American people that primarily inhabited the Merrimack River Valley of present day New Hampshire and Massachusetts, as well as a portion of southern Maine." It was during the time of the early European settlements that the Pennacooks were a large confederacy at odds with their northern Abenaki neighbors.

It has been recorded by early unknown historians that members of the Pennacook Confederacy were the following tribes: the Nashua, residing along the Merrimack River; the Souhegan or Natacook on the Souhegan River; the Amoskeag at Manchester; the Penacook proper at Concord; and the Winnipesaukee in Central New Hampshire. It is interesting to note that sometimes included were the Coosucs to the north, the Squamscots at Exeter, the Winnecowet at Hampton, the Piscataqua at Portsmouth and the Newichawanock near Rochester. The Amarascoggin had a village on the Androscoggin River at Lewiston, Maine, and were known to have roamed the eastern reaches of New Hampshire's North Country. The St. Francis Indians in Canada claimed portions of this area and ranged in the vicinity.

It was to this tribe that most of the New Hampshire Indians ultimately withdrew; however, little is heard about the Pennacooks as a separate tribe after Queen Anne's War.

The hills in this vicinity were named "Hana-ko-kees" by the Pennacook Indians. John Wainwright wrote in his diary in 1726 that the name of "a fall called 'Onna Hookline,' was taken from a hill of the same name."

In an old account of a scouting party led by Captain Ladd in 1746, "the body of water now called Lakin's Pond was referred to as Isle Hooks Pond." An old map of the location, dated 1639, locates the Anna Hooksett Hills. Several Indian relics have been found on the west side of the river and falls.

One of the first tribes to encounter European colonists, the Pennacooks were afflicted by diseases. Due to the illnesses, the tribe was weakened and subject to frequent raids by the Mohawks and Micmac tribes. Eventually, the Pennacooks fled north with their former enemies or west with other tribes, where they were hunted down and killed by English colonists. Those who survived joined other tribes in New York. Those who fled northward eventually merged with other New England tribes and Abenakis.

Saco and Soucook

South Outlet

Saco and Soucook are both English for *Sowacotuck*, an Indian word meaning "Burnt Pine Place" or "Burnt Pine River," from *sowa* (burnt), *coo* (pine) and *tuck* (river). The name describes the sandy plains adjoining the Soucook River in Merrimack County because they are covered with a heavy growth of pitch pine as they were back during the Indian days. The Soucook Plain extends from White Gate northward to Mill Brook in East Concord and from the eastern bluff of the Merrimack, at Sugar Ball, to the Soucook River at the Horse corner, a distance of about four miles.

The Pennacook Indians, with headquarters at Sugar Ball and Sewall's Falls, often camped along the Soucook River Valley, which extended from Penacook (now Concord) to Loudon and Gilmanton. From Loudon, they had trails to Clough's, Rocky, Shellcamp and Loon Ponds, where they trapped beavers and hunted moose, deer and bears.

When Champlain visited the Indian village at the mouth of the Saco River in 1605, he was told that the Indians living there were the Almouchiquois

and wrote of them as such, but twenty years later, they were known to the English settlers as the "Saco tribe." The tribe living near the upper Saco River was known to the English as Pigwackets (Peguakets), and their nearest neighbors were the Ossipee.

It might seem odd to us that none of the contemporary writers called the Indians of southwestern Maine "Sokokis" if we didn't already know it was a term used by the French and Indians at Quebec and Three Rivers, two or three hundred miles away.

The first writer to place the Sokokis on the Saco River seem to have been William Williamson, whose *History of Maine* was published in 1826. Williamson was obviously a century too late to have known the Saco Indians himself, and though he made good use of his materials, definitive information on the Sokokis was even less available to him than to us.

Chapter 3
INDIAN WARFARE

The Sokokis were considered the most feared of all the Indians of the Northeast, and the mere mention of the Pequawkets would have awakened fear in the heart of the boldest adventurer in the frontier settlements and frozen the blood of the timid with horror. So sudden were their movements, so well sustained and indescribably cruel their massacres, that the English never felt safe from their attacks. The least sound heard through the still night was interpreted to be the stealthy footsteps of the Pequawkets, and the listener expected each movement to be followd by their shrill war cry.

As the early settlers pushed north in the fertile lands of the Connecticut River Valley and other sections of northern New Hampshire, one of the first things they did when founding a settlement was to build a rude fort as a refuge from Indian raids. Fort Dummer was built to the north of Squaheag, now Northfield, Massachusetts. This was considered to have been the first permanent white settlement in what is now Vermont—at the time, the New Hampshire Grants.

THE ABENAKI WARFARE

When the Wampanoag people under King Philip fought the English colonists in New England in 1675, during King Philip's War, the Abenakis

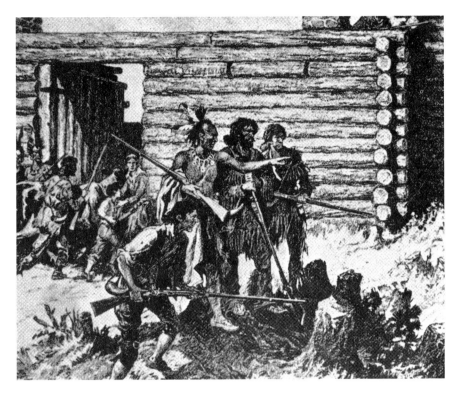

Above is pictured the early English settlers being pushed north from Fort Dummer, which was built to the north of Squaheag (Northfield, Massachusetts) up the Connecticut Valley. This is generally considered to have been the first permanent "white settlement" in the New Hampshire Grant. *Courtesy of National Life Insurance Co., Montpelier, Vermont, and Ernest E. Bisbee, 1946.*

joined the Wampanoags. The Abenakis pushed back the line of the early European settlement by devastating raids on scattered farmhouses and villages. The war was settled by a treaty of peace in 1678. As a result, the English flag waved triumphantly over the colonies. The barrier that had prevented the extension of the colonies westward was removed, and the French were practically eliminated as a factor in the further development of North America. The colonies were no longer menaced by a foe in their rear, while the Indians, deprived of their allies, were soon made to realize that they must remain on peaceful terms with the victors.

During the period from 1689 to 1763, New Hampshire engaged in five wars. Of these, the first two and the last two were with the French and the Indians, while the third was with the Indians alone, although French influence was largely responsible for it and was exerted throughout the

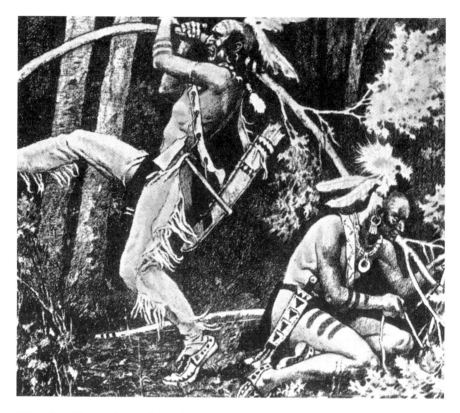

When the white men invaded the wilderness, they found the Indians had certain established trails that ran for long distances. The Indians always traveled these trails. To mark these trails, they would bend down young saplings here and there along the course of the trail and secure the tops to the ground. These trails were generally the shortest and easiest way to travel through the wilderness. *Courtesy of the National Life Insurance Co., Montpelier, Vermont, and Ernest E. Bisbee, 1946.*

struggle. For the greater part of this period, New Hampshire, like the other colonies, kept on the defensive. Sometimes, however, expeditions were sent into the interior for the purpose of surprising the Indians, breaking up their settlement and destroying their farmlands.

Unfortunately, as a means of defending themselves against the enemy, it became necessary for the European inhabitants to construct garrisons. These were house-forts, the sides of which were very thick and solid so that bullets could not penetrate them. Many of these garrisons were built in two stories, the upper one projecting over the lower, so that inmates could shoot with greater safety at those who attempted to break down the doors or set fire to the garrison. In many cases, flankers were built in the corners for the

Garrison Fort on the upper shore of the Connecticut River. *Author's private collection.*

use of lookouts. As an additional protection, the garrisons were generally surrounded by high picket fences.

In addition to the garrison, watchmen were appointed, and everything possible was done to guard against surprise attacks. When necessary, additional men were impressed to serve in the more exposed garrisons, and sometimes detachments of the militia were sent into the threatened region. As the Indians were seldom seen before they struck the contemplated blow, the report of the firearms or sounds of war whoops alone revealed their presence. The suspense in which the people were held for days and even months at a time may well be imagined.

The news that Indians were killing settlers came every now and then, and the settlers became uneasy wondering when they would strike again. Although little or no damage might be inflicted on the settlements during a season, the expenses incurred for defense were heavy. Often, small roving bands of Indians prowling through forests and lurking near the outskirts of the villages kept the frontier in a continual state of alarm. Periodically, scalping parties were so numerous that a person could not cross the threshold of a garrison without being fired on by the Indians, who often lay concealed behind rocks, bushes or tree trunks patiently waiting for just such an opportunity.

The inhabitants began to feel safe in their homes and the garrisons, and they became less aware of the hazards of confinement from the constant exposure to

danger. Too often, they exposed themselves unnecessarily and did not take the proper precautions. As a result, many lives were lost that could have been saved.

Hannah Duston

During the King William's War, Hannah Duston and her husband, Thomas, along with their nine children, were residents of Haverhill, Massachusetts. On March 15, 1657, the town was attacked by a group of Abenaki Indians from Quebec, Canada.

During this attack, Hannah witnessed the brutal killing of her baby and several of her neighbors. Twenty-seven colonists were killed, and thirteen were taken captive to be adopted or held as hostages for the French. When their farm was attacked, Thomas fled with eight children, but Hannah; newborn daughter, Martha; and nurse Mary Neff were captured and forced to march into the wilderness. Along the way, the Indians killed six-day-old Martha by smashing her against a tree.

Later, during her captivity, while detained on an island in the Merrimack River in present-day Boscawen, New Hampshire, Hannah acquired the assistance of two other English captives and scalped ten of the Indian family members while holding them hostage.

Six weeks later, at the mouth of the Contoocook and Merrimack Rivers, near what is now known as Penacook, New Hampshire, Hannah led a revolt against the Indians. She used a tomahawk to attack the sleeping Indians, killing one of the two men, two women and six children. One of the wounded female Indians and a young boy managed to escape the attack.

According to historian Patrick Allitt in his *City on the Hill*, "The former captives immediately left in a canoe, but not before taking scalps from the dead as proof of the incident and to collect a bounty."

They traveled down the river and, after several days, reached Haverhill. The Massachusetts court later gave them a reward for killing the Indians.

This event was well recorded by Cotton Mather in his *Magnalia Christi Americana* and retold during the nineteenth century by Nathaniel Hawthorne, John Greenleaf Whittier and Henry David Thoreau.

Many historians today consider Hannah Duston's actions again the Abenaki Indian family very controversial. Some consider her an American hero, while others say that she was killing other Americans. Some commentators believe her legend is racist and glorifies violence.

Cocheco

The Waldron Massacre

For many years after the establishment the town of Dover in 1623, the English setters peacefully coexisted with the Pennacook Indians. However, early in the fall of 1676, while the Indians of Canada were hammering away at the northern frontier settlements of New Hampshire, the renewal of hostilities along the Pascataqua River from Cocheco to Kittery in Maine occasioned the Alliance of Massachusetts to send two companies under Captain Joseph Lyll and William Hawthorne to arrest all Indians who were in any way involved in the recent uprising or were known to have killed any Englishmen in that part of the province.

Having set out in their expedition in the middle of the summer, the English came in the course of their march to Cocheco on September 5. They found four Indians assembled at the garrison of Major Waldron, with whom Wonalancet and his Pennacook tribes had made peace and in whom they confided as their brother and defender. At this time, more than four hundred Indians met at the Cocheco settlement. Many of them were strangers, and the other half were Wonalancet's people.

Tension mounted among the settlers and the Pennacook Indians over the following years. Chief Wonalancet was replaced by the warlike Kancamagus, who resented much of the injustice the English settlers inflicted on his people. It appeared that the Indians had no right to travel in the woods east of the Merrimack without permission from Major Waldron. More land was seized from the Indians for payments like a "peck of corn annually for each family."

Thirteen years passed, the call of defense was often heard through the province, and the massacre and plundering kept on, but the revenge of the Indians was not accomplished.

In that part of the settlement of Cocheco, which lay about the first falls of the Pascataqua River, were five garrisons; three on the north side (Waldron's, Otis's and Heard's) and two on the south side (Peter Coffin's and his son's). Surrounded by high timber walls and securely fastened by bolts and bars, the houses afforded a safe refuge for all the families who were subjected to an attack from the enemy. But by negligence, no watch was kept by night or day, and the Indians—who constantly passed through the town, visiting and trading, as was common in times of peace—watched the movements around the garrisons.

The plan for the execution of their revenge was in keeping with their method of warfare. Two squaws were to go to each of the houses and apply for lodging. The doors were to be unbolted by them when all had retired for the evening. Then, at a given signal, the massacre was to begin. Accordingly, on the night of Thursday, June 25, 1689, the squaws applied for admission to the houses and were admitted to all except the young Coffin's. They were shown, at their own request, how to open the doors in case they should have occasion to go out during the evening.

Mesandowit, one of the chiefs, was entertained by the major, and while at supper, he said, "Brother Waldron, what would you do if the strange Indians should come tonight?"

"I can assemble a hundred men by lifting my finger," answered the major.

Thus suspecting no harm from their guests, the people retired to rest after covering the coals on the hearth. About midnight, when all was quiet, the gates were opened, the signal given and the Indians rushed in, set a guard at the door and entered the major's room. Aroused by the noise, he immediately jumped out of bed and drove the intruders back into the kitchen, but while returning for his other arm, he was struck on the head by a hatchet. Dragging him to the hallway, his assailants seated him in a large, old chair and placed him on a table, asking, "Who shall judge Indians now?"

Then they compelled the people to prepare a meal, and when they had finished, each one cut the general across the breast and abdomen, saying, "I cross out my account." Cutting off his nose and ears, they forced them into his mouth, and when he was falling from loss of blood, one of them placed the major's own sword under him. Thus ending his misery, they also killed his son-in-law, Abraham Lee; took several others as captive; and pillaged and burned the house. Otis's garrison met the same fate. He was killed, and his wife and children were taken into captivity. Heard's garrison was saved by the barking of a dog, while Coffin's was spared, as the Indians had no enmity toward him. Proceeding to the house of the young Coffin, they summoned him to surrender, but he refused; then they took his father out, threatening to kill him if the command was not obeyed. The gates were immediately thrown open to the enemy.

Twenty-three people were killed during the attack, and twenty-nine were taken prisoners. After burning five or six houses, several barns and a mill, the invaders left the scene of devastation. They had accomplished the long-meditated revenge, whose record remains a dark memorial in the history of New Hampshire.

INDIAN WAR IN 1690–91

Reverend John Pike, the fourth settled minister in Dover, kept a journal in which the following entries appeared concerning Indian Outrages of 1690–91:

March 18, 1690—Salmon Falls was surprised by the Indians and French, just after the manner of Cocheco (1689). The whole place was destroyed by fire; twenty-seven persons killed and fifty-two carried captive.

July 4—Seven persons were slain, and a lad taken at Lamprey River.

July 5—The enemy advancing towards Exeter, set upon Hilton's Garrison, which Lt. Bancroft endeavoring to relieve, 8 or 9 of his men were slain.

July 6—Captain Floyd fought the enemy at Wheelwright's Pond, but was forced to retire, with the loss of 16 men.

July 7—The enemy came down upon Amesbury, took Captain Foot alive, killed Philip Rowell, and two more.

August 22—Phenehas Hull with his wife, and Robert Young, travelling betwixt York and Kittery, the said Young was killed by the Indians, and Hull's wife was taken, but himself escaped.

September 14—Amariscoggin Fort was taken on Sabbath day.

September 22—Fight at Mequoit near Casco, the enemy fled, after they had surprise[d] and ambushe[d,] slain and wounded 32 of our men; 8 of whom were killed, rest wounded.

January 25, 1691—Monday, ten o'clock in the morning, the Indians fell upon York, killed about 48 persons, whereof the Rev. Mr. Dummer was one, and carried captive 73.

September 28—David Hamilton, Henry Childe, etc., were slain by Indians at Nuvichawannock.

September 29—Many persons, to the number of 20 or 21 killed and carried away at Sandy Beach.

Sometime in July or August 1691, the French and Indians came upon the English forces under the conduct of Captain John March, Captain Daniel King, Captain Samuel Dhelburne and others at a place called Mequoit. When most of the soldiers were gone aboard the vessels, the officers on shore had a sharp conflict with the enemy but were forced to retire on shipboard, with the loss of Captain Sherburne and some others. Lieutenant John Allen was wounded along with many others.

Attack on Oyster River

It was historian Hobart Pillsbury who recorded that in the summer of 1694, the attack on Oyster River occurred. For almost a year prior to that time, there had been no hostilities with the Indians, for a treaty of peace had been concluded with them the previous August. As far as the French and English colonies were concerned, it was still considered a period of war. Realizing that a continuance of the peace would result in defeating their policy in the east, the French set their agents to work among the Indians, and in due time, they succeeded in getting a considerable number of them to take up the hatchet again. This accomplished, they singled out the scattered Oyster Village on Oyster River as the first object of attack. Then a few Indians were apparently sent forward to obtain information about the place. Although they were seen lurking about the neighborhood, their presence caused little uneasiness, for they always disappeared without doing mischief.

Hobart Pillsbury wrote the following concerning the attack:

> At last a band of between 200 and 300 hundred Indians, commanded by a French officer, cautiously advanced to the falls of the river. This they reached undiscovered on the evening of July 17. Although there were enough garrison houses in the village to shelter all the inhabitants, they were occupied at this time in most cases only by their owners and their families, for, as no attack was expected, most of the settlers slept in their own defenseless homes and only a loose watch was kept.
>
> When evening came and the inhabitants, unconscious of the awful calamity that was [about to] befall the place, had retired to rest, the savages quietly formed into two divisions—one for each side of the stream. For several miles on both sides of the river [that] might be effectually covered, each division soon afterwards broke up into many small bands, each of which was ordered to take up a position near some house and wait patiently under cover until a gun was fired as the signal for action.
>
> Fortunately for some of the settlers, one of their number had planned to go on a journey early the next morning. Having risen much earlier than usual, he started to leave the house, but just as he came out of the door he was fired upon and killed. Although some of the savages had not yet reached the places assigned them, the slaughter began wherever they were ready.
>
> Quietly breaking into the unprotected houses, the Indians either massacred or made most of the inmates prisoners, after which they deliberately set fire to the premises. Only a few eluded their vigilance and escaped to places of

safety. Of the twelve garrison houses in the settlement, three were abandoned by the occupants, most of whom succeeded in effecting their escape, and two were taken without a struggle, most of the inmates being murdered, while the remaining seven were successfully defended.

When at last the Indians withdrew, at least twenty houses were in ashes, nearly 100 of the inhabitants lay dead and almost thirty others were in the hands of the assailants.

A short time later, a small party crossed the Piscataqua and killed Mrs. Ursula Cutt and three of her servants as they were laboring in the field, which was situated two miles from Portsmouth, while a larger group traveled westward and fell on the settlement near Groton, Massachusetts, killing and capturing forty persons. According to the French, this attack accomplished its purpose, for it certainly broke off all talk of peace between the Indians and the English settlers.

Dr. Jeremy Belknap's account of Oyster River, unlike that of Hobart Pillsbury's observation, is an interesting account of this terrible destruction. Dr. Belknap's account is given as follows:

Oyster River is a stream which runs into the western branch of the Piscataqua; the settlements were on both sides of it, and the houses chiefly near the water. There were twelve garrisoned houses, sufficient for the defense of the inhabitants; but apprehending no danger, some families remained at their own unfortified houses, and those who were in the garrisons were but indifferently provided for defense, some being even destitute of powder. The enemy approached the place undiscovered, and halted near the falls on Tuesday evening, the 17th of July. Here they formed into two divisions, one of which was to go on each side of the river and plant themselves in ambush, in small parties, near every house, so as to be ready for the attack at the rising of the sun; the first gun to be the signal. John Dean, whose house stood by the saw-mill at the falls, intending to go from home very early, arose before the dawn of the day, and was shot as he came out of the door. Their firing, in part, disconcerted their plans; several parties, who had some distance to go, had not then arrived at their station; the people in general were immediately alarmed, some of them had time to make their escape, and others to prepare for their defense. The signal being given, the attack began in all parts where the enemy was ready.

Of the twelve garrisoned houses, five were destroyed, viz., Adams', Drews', Edgerlys', Meders', and Beards'. They entered Adams' without

resistance where they killed fourteen persons; one of them, being a woman with child, they ripped open. The grave is still to be seen where they were all buried. Drew surrendered his garrison, on the promise of security, but was murdered when he fell into their hands; one of his children, a boy nine years old, was made to run through a lane of Indians as a mark for them to throw their hatchets at, till they had dispatched him. Edgerly's was evacuated; the people took to their boats, and one of them was mortally wounded before they got out of reach of the enemy's shot. Beard's and Meder's were also evacuated, and the people escaped.

The defenders' houses were nearly all set on fire, the inhabitants being either killed or taken in them, or else, in endeavoring to fly to the garrisons, some escaped by hiding in the bushes, and other secret places. Thomas Edgerly, by concealing himself in his cellar, preserved his house, though twice set on fire. The house of John Bass, the minister, was destroyed with a valuable library. He was absent; his wife and family fled into the woods and escaped. The wife of John Drew, at whom the first gun was fired, was taken, with her daughter, and carried about two miles up the river, where they were left under the care of an old Indian, while the others returned to their bloody work. The Indian complained of a pain in his head, and asked the woman what would be a proper remedy; she answered, "occapee," which is the Indian word for rum, of which she knew [they] had taken a bottle from her home. The remedy being agreeable, he took a large dose and fell asleep; and she took that opportunity to escape, with her child, into the woods, and kept concealed until they were gone.

A Battle of Barber's Mountain

Historian George B. Upham, wrote of "An Indian Fight," for the *Granite Monthly* in September 1919:

On a blazing hot August more than three hundred years ago, two canoes might have been seen gliding down the reach of the Connecticut River near the town of Claremont. In these canoes were six men "on Her Majesty's, Queen Anne's Service."

For a long span of time, nothing had been heard except the dip of the paddles. When abreast of the near slope of Ascutney, Robert Barber broke the silence by calling to the occupants of the other canoes, "Hey there! I

question if we could do better then go to the summit of yonder mountain you see ahead to look out for smoke." The answer, "We'll do that," sounded across the water.

An hour or two before sunset, the canoes were pushed to the eastern shore, gently lifted from the water, carried a short distance and hidden in the thick undergrowth above the high-water mark. The small party then slung the knapsacks, shouldered their long-barreled flintlock muskets and disappeared into the forest. It was not difficult to climb the mountain, since some of the slopes were grassland, burnt over by the Indians of seasons past. They reached the rock-bare summit and looked in every direction; no smoke or other signs of the foe were visible. Then, after sunset, they descended a short distance to the wall [that] protected the little village to the south. Here they built a small fire and prepared their evening meal.

In the morning, Robert Barber and his party were on their way down to their canoes, when suddenly a sharp crack of a musket sounded. Barber was seen to fall but almost instantly to [rally. He] rose to his knees, took deliberate aim and fired. An animal-like screech [from] an Indian showed that his shot had counted. Martin Kellogg, just behind him, fired an instant later and another [scream] told a similar story. The four other scouts a short distance behind, seeing Kellogg immediately surrounded by a dozen Indians and hearing the cries of others coming, broke for cover and were lost to view in the thick undergrowth.

This event took place on Barber Mountain in August 1708. The survival of the name and the preservation of [early American history] records enable us to fix the place of the battle. The settlers had learned that safety depended on being forewarned by these raids, and therefore, during this and the several succeeding wars, [they] sent a surprising number of scouting parties far up the river, sometimes keeping such parties out for several continuous months. Many town records show that they were instructed "to go to ye mountain tops and to lodge and view morning and evening for smoke," the smoke of campfires being the best way of detecting the presence of Indians over wide areas.

In August 1708, one of these scouting parties was sent out from Deerfield in canoes. With it was Robert Barber, a son of Josiah Barber of Windsor, Connecticut, and Martin Kellogg, then twenty-two years old, who, four years before, had been taken captive at the "Sack of Deerfield" and carried to Canada. They proceeded as far as White River, which at the time was accounted to be [120] miles up the Connecticut River from Deerfield.

The party was under instructions to scout near the mouth of White River for the valley with the Winooski—the route followed by the Central Vermont Railroad.

In the "Journal and Records" of Reverend Stephen Williams, one of the captives taken at the "Sack of Deerfield" in 1703, we find the following:

> *August, 1708. A scout of six men, about a hundred miles above Deerfield were fell upon* [by] *a party of Indians, and one Robert Barber of Windsor was slain; but after he had received his mortal* [wound]*, he got upon his knees and shot the very Indian that shot him, and fell down and died. So that when the Indians came to them, which was within a few minutes, they were both dead, lying within a few rods of one another. This account I had* [from] *an Indian, who, relating the matter, added, "No, he is not Barber, but his ghost." At the same time Martin Kellogg was taken, which was the second time of his going into captivity, but before he was taken,* [he] *discharged his gun and wounded an Indian in his thigh.*

Captain Benjamin Wright, who led many scouting parties up the river, recorded in the report of his scout, which started from Deerfield about April 26, 1709, with sixteen men, that they "travelled up the Connecticut River, a distance which usually called one hundred and twenty miles…to the mouth of White River." The latter place is twenty miles north of Barber Mountain, placing that mountain, according to early memory of distance, just one hundred miles up the river from Deerfield.

It is quite likely that one or more of the four who escaped in August 1708 was with Captain Wright on his previously mentioned scout eight months later. If so, they would most likely have pointed out the place called Barber's Mountain. It is probable that other scouting parties had passed there during the months that intervened and that this place was well known by that time. If no survivor was present with them, it would have been easy to describe the scene of the fight as on the only mountain close to the river, on the east side, about halfway between the Great Falls and White River. It is, however, not necessary to rely on conjecture of the place given to others, for we know of Martin Kellogg's return from his second captivity and of his later participation in various scouting expeditions up the river. One of these was in April and May 1712, with Captain Thomas Baker and thirty-two men. It went up to Cowess (Haverhill). Kellogg would have good reason to recollect the place and to point it out to his companions. The Indians also pointed out the place for a belief that it was not Barber but his ghost that arose and

shot the Indian who shot him; this apparently made a deep impression on their minds.

The preceding facts, and the fact that Charlestown No. 4 was settled in 1740, only thirty-two years after this fight took place, seems quite sufficient to account for the survival of the name until the first settlers came to Claremont in 1762.

Undoubtedly, there were many other passings on the river, the records of which had been lost or about which nothing was ever written. The old Cheshire County records fail to indicate that anyone named Barber ever owned land on this mountain. No one of that name is known to have lived there. There seems little doubt that the fact previously stated accounts for the oldest geographical name in Claremont.

FORT AT NO. 4

It was during the early 1740s that several families purchased grants from the original land speculators and made their homes. Three brothers, Steven, Samuel and David Farnsworth, were known to be the first settlers of No. 4. Later, they were joined by the Stevens, Hastings, Willard, Parker and Johnson families, all of whom played important roles in the settlement history.

According to the Living History Museum at No. 4:

> *Fort No. 4 was the northern most settlement of the English colonies at this time. The closest settlement of any kind to No. 4 was Fort Dummer, about 40 miles to the south. Across the Connecticut River to the west lay a wilderness claimed by both New Hampshire and New York, yet long inhabited by the western Abenaki tribe. Farther west and to the north was New France; this area, including what would become Canada, was claimed by England's rival France. In this age of colonialism, the French laid claim to the area from Louisiana through the Ohio River Valley. The St. Lawrence River gave the French unlimited access into the distant western frontier, allowing them to build a string of forts and trading posts. This placed No. 4 on the edge of competing territory between two leading international powers of the time period.*
>
> *During the early days of the Grants, a band of Indians descended on a settlement near White River and among other captives took as prisoners the children of Hannah Handy. Although distracted by her loss, this brave woman*

Hannah Handy taken captive by Indians. *Courtesy of National Life Insurance Co., Montpelier, Vermont, and Ernest E. Bisbee, 1946.*

followed the Indians' trail alone and unarmed until she reached the banks of the White River where a friendly Waubanakee carried her across the swift waters on his back. It is recorded that she then proceeded to the camp of the captors and demanded her children returned. Her courage so amazed the Indian men that they released her children and permitted her to take them back home unharmed.

The families of No. 4 cooperatively farmed the land, built their homes and operated businesses. In 1743, a fort was erected to protect the frontier, and four years later, Captain Stevens, with thirty rangers, heroically defended the place against seven hundred French and Indians for five days. The invaders, finding that they could not overcome the English with musketry fire and the wind being very high, set fire to all the old fences and to the neighboring log cabins so that in a very short time, the fort was completely surrounded by flames. Fire arrows were also discharged, setting the fort itself on fire in

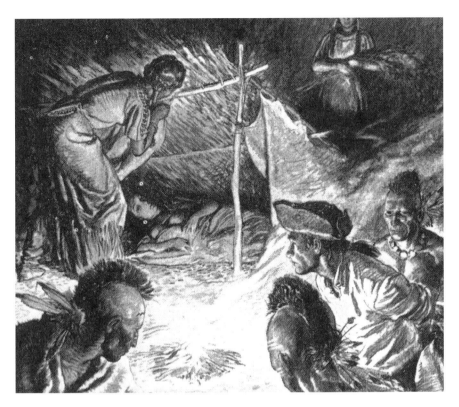

The capture of Captain Johnson and his wife in their attack on Fort No. 4 on August 31, 1754. *Courtesy of the National Life Insurance Co., Montpelier, Vermont, and Ernest E. Bisbee, 1946.*

many places. The defenders dug ditches under the bottom of the stockade so that they could crawl under and throw water with buckets from the outside of the blazing structure without getting shot. In this way, by incessant labor, they managed to keep the fort from burning down.

All attempts failing, the Indians filled a cart with wood and, setting it on fire, rolled it down toward the fort. Finally, tiring of the siege, the attackers proposed a parley and offered the defenders their lives and food enough to take them to Montreal, where they would take them as prisoners. Captain Stevens assembled his men and put it to a vote, and the answer was they were determined to fight it out to the last man. Finally, on the fifth day, the Indians were getting restless, so they retired.

This historic defense of the gateway to the settlements north and west was truly an American victory and a page in our early history that is little known to the public.

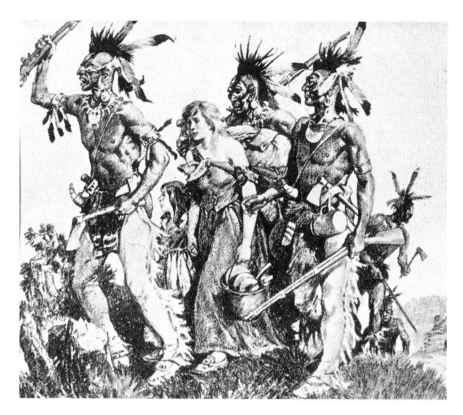

Mrs. Johnson and one other woman taken captive by Indians when they raided Fort No. 4. *Courtesy of the National Life Insurance Co., Montpelier, Vermont, and Ernest E. Bisbee, 1946.*

Another noted raid on Fort No. 4 occurred on August 31, 1754. The night before the attack, there had been a joyous party in Captain Johnson's cabin, whose dwelling was the most northerly one in the settlement. Everyone had a fine celebration upon his return from a trip downriver. Retiring late, the captain was aroused at sunrise by a neighboring carpenter knocking at his door, having come according to an agreement to do some work for him. As the captain opened the door to let him in, Indians pushed by and rushed in. After binding the captain and pulling the women out of their beds, the intruders plundered the house and set out with seven captives.

Mrs. Johnson, one of two female captives, was in a pitiable condition, being with child, but happening to catch an old horse on the meadow as they were leaving, they permitted her to ride. Pushing on all day, they made camp that evening not far from Mount Ascutney. The following day, Mrs. Johnson gave birth to her baby and the party halted, but the next morning, weak

as she was, she was forced to get on the horse and ride. She was, however, permitted every hour to get off the horse and rest a few moments on the ground. A day or two later, running out of food, the horse was killed and eaten with great relish by the entire party. Mrs. Johnson now tried to walk, but the exertion was too much, causing her to faint. The Indians then made a packsaddle for her husband's back, and he managed to carry her through the rest of the day.

In this manner, the party finally managed to cross Vermont and reach Lake Champlain. From there, they went by boat to St. Francis. The prisoners were purchased from the Indians by the French and, after several years, were either ransomed or permitted to return home.

A Great Indian Battle

Dorsey W. Hyde of Gilmanton, New Hampshire, related the following Indian history:

> Colonel Thomas Westbrook was ordered, with a party of men, to surprise Norridgewock, and seize upon Sebastian Ralle, a Romish priest, who was there residing with Indians to commit depredation on the new settlement of New Hampshire. Ralle [sic] himself escaped from their hands, but the Indians obtained a strongbox of papers, among which were letters from the Governor of Canada showing a conspiracy in exciting the Indian hostilities.
>
> The Gilmanton History discloses that here were two bloody wars with the French and Indians, and enemy scouting parties ranged the forests and rendered the situation of the frontier settlements exceedingly dangerous. Although there was no large scale battle, Gilmantonians "could hardly venture out to milk the cows. The Indians destroyed their crops, broke down their fences, and laid open their fields, and their horses and cattle were killed. Often did the war whoops wake the sleep of the cradle, and many of the inhabitants were taken and killed." A few men passed the winter of 1749–50 in Gilmanton, but "they withdrew in the spring…as it appeared that the Indian hostilities had not permanently ceased.

At the head on the right bank of that part of the Winnipesaukee River, once known as Little Bay and later named Silver Lake, there were found by the

early settlers the remains of an ancient fortification. Hayward's *New England Gazeteer* says the following:

> *This fort consisted originally of six walls, one extending along the river across a point of land into the bay and the other in right angles, connected by a circular wall in the reed. Traces of these walls were still to be seen in 1841, though most of these stones of which they were composed had been removed to a dam thrown across the river at this place. Within the fort, as well as on an island* [Atkinson's] *in the bay, had then been found numbers of Indian relics.*

Historians believe that about the time the Pequawkets and Pennacooks formed a confederation to defend themselves from the Mohawks. With the Pequawkets inhabiting the eastern part of the state and the Pennacooks around Concord, the Winnipesaukee River would have been a natural route of communication.

M.B. Goodwin, editor of the *Merrimack Journal* in 1872 and author of *Rambles and Reminisces*, connected the fort with a big Indian battle. He wrote the following: "There is little doubt that if the fort was the work of Pennacooks, who fled to this spot and built themselves a stronghold after a disastrous battle with the Mohawks on the Concord intervals."

The following essay submitted by Chandler E. Potter, "The Penacooks," is as follows:

> *Tradition has left but a meager sketch of this last battle in and around the old fort. The Mohawks, whose thirst for blood was not satisfied by the slaughter on the Concord intervals, learning of the whereabouts of the remnant of the Penacooks, followed by considerable numbers of their stronghold at the head of the Little Bay. The first attack was made on the north side of the fort. While the battle was here raging the weak and the feeble of the Penacooks were sent to the canoes, which were moored on the south side. The whole garrison followed them and were soon beyond the reach of pursuit, safely landing on Tom's Island (another name for Atkinson's Island, after one Thomas Bowen, an earlier owner).*

The Mohawks retired but were afterward joined by a war party of allies from Canada and returned to the fort. This time, a powerful attack was made on the south side. The canoes were secured, the fort entered and the garrison overpowered and massacred. A few fled up the river and bay a

short distance, but in attempting to cross a point of land running from the Belmont shore nearly across the stream, they were overtaken and slain. This point has since been known as Mohawk Point.

Historian and author Solon B. Colby of Meredith, New Hampshire, rendered the Goodwin account of the Mohawk-Pennacook battle, along with the following description of the fortification, which was taken from *Rambles about the Weirs* by Edgar H. Wilcomb:

> *At East Tilton, on the Sanbornton side of the Winnipesaukee River are the remains of an extensive ancient fortress, unquestionably constructed by the Indians, surrounded by evidence of at least one great battle. As late as 1800 the stone and earthen walls were in fairly good condition. Since then they have been demolished to supply material for a nearby dam, and only a few mounds and some scattered stones remain. Around the site of the old walled fort, numerous skeletons have been exhumed, some with cleft skulls, evidence of the tomahawk's work in hotly contested fights between savage hordes.*
>
> *Most of these were uncovered when the railroad was built back of the fort site, and there are doubtless other concealed in the soil around the old fort and on an island in the river where there are evidences that the battle also raged.*

According to historian Solon Colby, who had done considerable research on both "dusty tomes and muddy subsoil," had come to the conclusion that most of the tales on Indian battles, interesting as they are, have no foundation in fact.

During Mr. Colby's research, he cited a number of facts to support his proof of this theory. Findings by the New Hampshire Archeological Society of pipes, axes, pottery and other artifacts indicate positively that the Algonquians had established villages and a cemetery at this location over a long period of time. Storage pits and trenches on Clark's Island indicated that the Indians had an ordinary stockade fort for the protection against enemy tribes, but Mr. Colby also stated that "the Indians had no permanent villages along the Winnipesaukee basin after 1700, although they did come from time to time to fish and make raids on frontier settlements."

Colby continues with the following research:

> *When the fort was destroyed in 1814, and its stones removed for the purpose of building a dam, people had meager knowledge of Indian culture. Therefore when they came upon axes, spearheads, pipes, pottery,*

and ornaments, which Col. Atkinson's men had carelessly shoveled into the walls of their fort, they erroneously concluded Atkinson's fort had been an Indian stronghold. They did not stop to realize that the Indians' heaviest weapon was a spear or an arrow, and that three or four feet of masonry would have been preposterous defense against projectiles, which could be stopped by a two inch plant. Nor was it realized in 1814 that Indians wouldn't dream of building a fort on a cemetery site. Such sacrilege could cause the Evil Spirit to decree a crop failure upon the offenders.

Some historians based the estimate of the fort's age upon the size of the oak trees found growing within the enclosure, but it was a custom, when building a fortification of this type to leave some hardwoods standing for emergency fuel supply. A standing tree took less room than one cut and piled, and it could always be cut if needed.

In conclusion, Mr. Colby cited the testimony of Lilas Bamford, whose ancestors were the first settlers at this site. She described the origin of the fort and pointed out that the mounds in front of the openings of the fort were gun emplacements for the three small cannons that Colonel Atkinson's men brought with them. The troops occupied this fort until they were paid off and disbanded in October 1747.

Indian Conflicts with English Settlers

Queen Anne's War (1702–13)

During Queen Anne's War, New Hampshire was subjected to minor Indian forays. This conflict with the Indians was identified as the Fourth Indian War. Later, in 1722, there was an undeclared war called Lovewell's War, from the name of the popular hero of the conflict. It was with the Pequawket Indians alone and was concluded in 1725, when Captain Lovewell and his New Hampshire militia came on some hostile Indians near Conway. After the encounter, Indian hostilities were curbed for two decades.

Fear of Indian attacks, however, had hindered further colonization. For many years, the colonists of New Hampshire had to fight for their homes. Indians lay in waiting for them, proprietors sought to rob them of their property, kings usurped the government and the French hired Indians to murder them. The marvel is not that colonization was so slow but that any

settlers remained to colonize. The population in 1732, more than a century after the first settlement, was only about 12,500.

THE DEATH OF CHIEF PAUGUS

Ernest E. Bisbee's *The White Mountains Scrap Book* provides the following excerpts:

Two months later, Captain Lovewell set out again, this time with the force of forty-six men, for the Indian village of Pegwagget. Arriving at Ossipee Lake, he built a small fort as a refuge in case of trouble and left a few men to guard it. While they had been trooping through Fryeburg, Maine, they lay encamped not far from the Indian village of Pegwagget, and not knowing how to proceed, they marched to the north on the following Saturday. While on the move, they were facing an entire Sokokis tribe. Here a desperate battle now took place from behind trunks of the pine trees, the Indians howling and yelling like wolves while the English shouted and took cover. It was Paugus who led the Pequot tribe, and as a running fox and howling wolf, he charged the English.

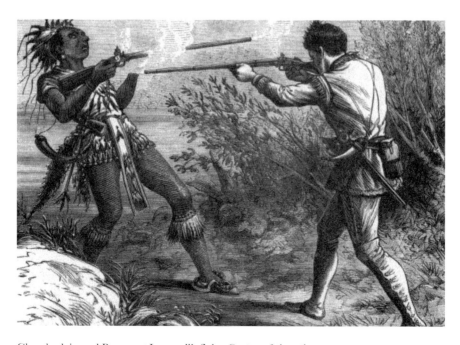

Chamberlain and Paugus at Lovewell's fight. *Courtesy of the author.*

After the battle had gone on for a long time, one of the rangers stepped down to the pond to cleanse his rifle, which had become fouled by constant firing. Upon merging on the shore, he saw an Indian—the dreaded chief Paugus. Watching each other closely, they carefully dried their weapons and then commenced loading at the same time, the balls in each gun being sent home by their ramrods at the same instant. "Me kill 'um," said Paugus, starting to prime his weapon with his powder horn. "The chief lies," said the ranger, striking the breech of his gun sharply on the beach, whereupon it primed itself, being badly worn. A moment later, Chief Paugus lay dead, shot through the heart.

The deadly little battle continued until dark, when the enemy seemingly withdrew, but the rangers, fearing a further conflict, stood guard until midnight. They left the loaded guns in the hands of their wounded, so that they could sell their lives dearly on the morrow, they divided into three parties, fearing to leave too large a track for the Indians to follow on. One of the parties reached the fort at Ossipee, only to find it deserted. It seems one ranger had proved a coward and deserted at the beginning of the fight, and fleeing to the fort, he had told such a fearful tale that the defenders all struck out for home. After incredible hardships, most of the survivors of the battle reached home.

The Indians, losing their renowned leader Paugus, became disheartened, and most of them withdrew to the upper waters of the Connecticut and eventually to St. Francis, though a few stragglers remained in the mountains. Thus passed the dreaded Sokokis.

Suffering more severely from the ravages of Indian attacks, than other localities, were the English frontier settlements of Dover and Durham. The Massachusetts and New Hampshire colonies combined forces at various times and enlisted considerable bodies to cope with and destroy the marauders. Finally, a bounty of £500 was offered for every Indian scalp secured, which induced many volunteer companies to be formed, though little is recorded as to results, or Indian casualties, which were likely to have been quite numerous.

One of these companies encountered a small band of Indians east of the Belknap Mountains and killed one of them, who appeared to be an individual of distinction. He wore a coronet of fur, colored scarlet, and his hair indicated that he could not be a full-blooded Indian, but rather a Canadian half-breed. A devotional book and a list of names of 150 Indians were found on his person. It was afterward ascertained that he was a Catholic priest, Father Sébastien Rale, a Jesuit, and that

he had allied himself with the French and the Indians against the New England settlers.

At the time, the French Canadians were ready to excite jealousies and discontent among the Indians and had employed Rale to encourage them in acts of depredation. He secretly engaged to supply them with arms and ammunition and increased their prejudices against the English by exaggerating the causes of their discontent.

The Indians complained that the treaties made with them had been violated; that promised trading facilities had not been established; that encroachment had been made on their hunting grounds, which drove away their game; and that the building of dams on the rivers and streams was destroying their fisheries. The settlers were also accused of destroying their cornfields.

Knowledge concerning this trouble-making Rale had been gained sometime before his death, and arrangements had been made to seize him at a log cabin where he was known to be stopping temporarily, but he succeeded in escaping, though he left evidence about the complicity of French Canadians who were backing him and the Indians who were being excited to numerous deeds of violence.

As the Indians were constantly becoming more troublesome, garrisons were formed and stocked with provisions and military supplies at Durham and other frontier points, and scouting parties were kept on the alert.

At Durham, the Indians made a furious attack on Captain Chesley's small company, which happened to be caught outside the stockade, and killed seven of his men at the first fire. The rest of the white men fought vigorously but were soon overpowered by superior numbers, and all were killed.

The annals of Portsmouth mention an expedition from Portsmouth to Lake Winnipesaukee in 1689 under Captain Wincol to suppress an Indian insurrection, resulting in the killing of a few Indians, and refer to massacres by the Indians at Major Waldron's and other garrison houses at and near Dover "with circumstances of unparalleled cruelties." The following are excerpts of that account:

In the fall of 1695, Isaac Bradley and Joseph Whittaker were taken captive by the Indians at Haverhill, Massachusetts, and were held at the lake all winter. They escaped the following spring and after nine days in the woods arrived safely at Saco, on the seashore.

In 1709, two of Captain Jeremiah Gilman's sons were captured by the Indians during the raid and massacre near Newmarket. One was burned

at the stake, while the other was taken to Canada and imprisoned by the French allies. The latter son, Andrew, escaped and found his way back to the home of his son, Winthrop, then living in Gilmantown [Gilmanton]. Together they went over the trail, found the spot where the young man had been burned at the stake and identified various campgrounds in the Lakes Region through which the raiding party had passed on their way northward. The trail led by the eastern shore of the lake, the marauding Indians and their allies, the French, always seeming to avoid the Winnipesaukee River territory, which was then inhabited by peaceful Indians.

In 1723, Governor Wentworth informed the general assembly that by advice of the field officers he had sent a "party of men to Winnepishokee Pond, under command of Captain John Gillman. They are gone twelve days march to the part of the pond where the fishing is fixed, in order to make what discovery they can of the enemy."

Later, in 1747, it is written that "owing to anticipated French and Indian troubles, Col. Atkinson's regiment march to Lake Winnipesaukee, from Portsmouth, and the frontiers, where they remained during the winter, undisturbed by the Indians, while other parts of the country were suffering by their ravages."

A staff contributor of *Granite State Monthly* in 1906 gave these excerpts of that account on the Merrimack:

For forty years, beginning with the year 1675, Haverhill on the Merrimack River was the foremost frontier town and suffered greatly from depredations of the Indians. During this time, there were several severe attacks and one massacre, in which many people were killed. Thus, all the town's inhabitants were constantly put on the alert.

During the times of constant Indian menace, all houses were built of logs with loopholes through which guns could be fired and projecting upper portions that enabled the guards to shoot downward when the Indians approached closely and sometimes attempted to set fire to the bases of the buildings.

The men always had their guns ready for instant use, even on the Sabbath, while attending church or other gatherings. They were also prepared while at work in the fields and elsewhere.

In the Provincial records of 1743 is found a petition from the Indians for a "truck house" (probably a trading post), which asked that it be "set at a place which we call the carrying place, which is on the east side of the river which runs out of Winniupissioke Pond against the mouth of the

Pemichewassue River." This location was construed to mean at or near the junction of the Winnipesaukee and Pemigewasset Rivers at Franklin.

In May 1754, Nathaniel Maloon, his wife and three children were captured by the Indians at a place near Franklin Falls, then known as Bakers Town, afterward as Stevenstown. Only one member of the family—the eldest boy, who happened to be in the woods nearby—escaped. The family was compelled to journey on foot through the wilderness to Canada, the youngest child dying on the way—killed, no doubt. Afterward, it was ascertained that three of the four surviving capture—Maloon, his wife and one son—were sold to the Canadians to become slaves, the daughter being retained by the Indians. The suffering of this family and many others subjected to similar cruelties must have been terrible. Few were ever heard of afterward. Many died at the hands of their captors. The log cabin where this family lived was found stripped of all the furnishings, all except the feathers from the beds being carried away. It is a wonder they did not burn the cabin.

The same band of Indians that seized and carried away the Maloon family afterward attacked the William Emery cabin in the vicinity during the family's absence. Others who suffered during this raid were Mrs. Call and a man named Cook. The latter was killed and scalped.

There were many local Indian depredations in 1754. The Indians raided white settlers in Canterbury but were generally repelled by the watchful and well-armed residents. Josiah Mills and James Lindsey were wounded during this raid.

In a 1754 report to Governor Wentworth, Colonel Joseph Blanchard, who was stationed at Stevenstown in a temporary fort with a force of sixty men, stated that "the news I have from all quarters makes me afraid there's a considerable number of Indians scattered in the frontiers." He further reported, "I expect every minute to hear of further attacks, unless the people give more attention to their guards."

On July 25, 1755, Colonel Blanchard reported having just left the Stevenstown blockhouse with an advance force and most of the supplies for Charlestown, located on the Connecticut River. Two divisions of two companies at Forts Dummer and Albany went back to Charlestown Fort No. 4, leaving a small force at Stevenstown. Continued trouble with the Indians retarded settlement greatly in New Hampshire until about 1770, when they were entirely subdued and a treaty with them was concluded.

Often, during the long marches that followed for nourishment, supplies became scarce, and frequently hunger and starvation took command of their travel. Many died on the way. When one's strength was almost gone and his or her inability to keep up with the party became apparent, a blow from the hatchet quickly put an end to his or her sufferings. When we consider the many miles they had to travel, half naked and barefoot through pathless forests, through frost, exposed by day and night to the inclemency of the weather, we can describe only their trials and tribulations. The mental anguish they suffered can only be imagined.

Although the people of New Hampshire were practically forced by circumstances to keep on the defensive, they fully realized the advantages that would accrue to them if the Indians could only be kept at a greater distance from the frontier. Accordingly, expeditions were sent to the White Mountains, where it was most likely that the Abenakis and Sokokis could be found. By laying waste to the latter's planting grounds and breaking up their settlements in the region, the settlers virtually compelled them to seek places of greater safety farther north.

As the New Hampshire Indians' planting grounds were invariable ruined whenever seen and their stored corn destroyed whenever found, food often became scarce. Numerous times, famine set in, and many deaths naturally followed. Moreover, as the Indians were inclined to go farther inland when pursued, these undertakings most likely saved the border from many raids. However, exposure, disease and starvation probably did more to thin the ranks of the Indian communities than anything else; it was expeditions of this character that finally broke the power of the Indians in the regions of the North Country.

We are unable to ascertain that there were ever any serious difficulties with the Aquadoctan Indians, located around the Weirs. They seemed to be peaceably inclined toward the white settlers. The various encounters mentioned in the Lakes Region occurred east and south of the Belknap Mountain Range.

Finally, some of the tribes were so reduced in numbers that they united with their neighbors for protection, while others withdrew entirely from their camps and joined the tribes in French territory, like in St. Francis in the North Country and Canada. At the close of the eighteenth century, the Indians actually living within the limits of New Hampshire were so few that they were never a source of trouble thereafter.

Attack on St. Francis Indians

October 4, 1759

Director of cultural affairs Réjean OBomsawin of the Abenaki Nation of Odanak, Canada, gives the following account:

> *On the early morning of October 4, 1759, the St. Francis Indian village (Alsigunticook) was attacked by Major Robert Rogers and his rangers. Most of our warriors were participating in the Battle of Plains of Abraham on the side of Montcalm and its troops. Was it really a noteworthy accomplishment according to American history? Is it an act of bravery to slaughter elders, women and children on the account of about two hundred souls? Mrs. Malian OBomsawin and I recalled what their great haunt told them about this massacre. She was at the time a little girl with her mom in the village celebrating fall harvest when Major Robert Rogers and his men attacked the village at dawn. She and her mother went to hide in the cornfield. To keep her from crying, her mother gave her maple sugar taffy.*
>
> *They saw soldiers with red coats setting fire to the field and to all the shelters including the church; they were so scared to be slaughtered like the others. Perhaps it is time to include in American history indigenous points of view and give a better picture of the situation at the time of the colonies' settling in the New World. Major Rogers was given clear instructions to give a lesson to the St. Francis Indians, not to make them angry. Following this event, history recalled so many raids in the English villages from the St. Francis Indians. The result of Major Rogers and his rangers' cowardly attack did not improve the relationship with Europeans who settled on Abenakis ancestral territory.*

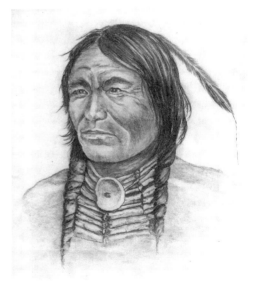

Indian warrior. *Courtesy of the author.*

INDIAN LEGENDS AND FOLKLORE

The following Indian legends and folklore tales have been assembled from a potpourri of unknown writers. Many of these stories are myths and were passed down from generation to generation or are purely mythological renderings of the imagination. Some of these stories have been assembled into portfolios or published in nineteenth-century periodicals without the authors' names or references' names. I have seen many printings of the same stories; thus, the unidentified material (published or otherwise) is not necessarily that of my work but rather a rendering of these Indian legends. These stories are meant to amuse and enlighten the traditions and Indian heritage so as to reflect the nostalgia of their lifestyle.

It is without malice or deception of source that I have included some of these stories as myths because they are fascination and add drama to the spirit of the Abenaki Nation.

WAUMBEK METHNA

Ernest E. Bisbee in "The White Mountain Scrap Book" reminisces about the Native Americans in the mountains:

> *Our mountains are monuments of the creator's work of world building; our valley is the sentinel of his greatness. They are noted not only for the grandeur of their majestic presence but also as sources of busy rivers that*

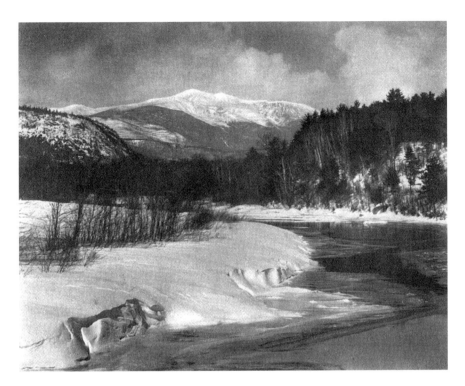

Mount Washington and the Saco River in the winter. *Courtesy of the author.*

control the progress of industry, the barriers between empires, the refuge of the seekers of freedom. Mountains are ever objects of respect to those who dwell under the shadow of their dominion. The mountains not only protect their inhabitants from the biting blasts of the northland, but they unfold from their lofty summits the very scroll of nature's handiwork.

The spirit of the mountain is always the song of hope and freedom of the Native Americans. For the Abenaki Nation, the White Mountains were known by the poetical designation of *Waumbek Methna*, the mountains of the "Snowy Forehead." These lofty summits were looked on as hallowed retreats where it was believed only the chosen of the Great Spirits could ascend. Their name for the highest was *Agiochook*, which meant, the "Home of the Great Spirit."

A 1700s historian by the name of John Spaulding eloquently wrote in his journal:

In olden times, from far and near, have come the brave and fair red children of the wilderness to offer, in wild, shadowy glens, their sacrifices of vengeance and love, and where their songs rose, with the echoes of the thundering waterfalls, to mingle with the roaring wind of the tempest cloud, upon the snow-crowned rock, there they reverently believed the Great Spirit listened and satisfaction to their tribute of esteem. When the first white man came here to climb to the top of this bald mountain, an old Indian, with his tomahawk of stone, flint-pointed arrow, and tanned war dress, from the skins of moose and bear, standing proudly erect, shook his head and said, "The Great Spirit dwells there; he covers steps above the green leaves with the darkness of the fire tempest. No footmarks are seen returning from his home in the clouds."

In all of nature's artistry, there was nothing so beautiful as the masterpiece of the Great Stone Face and the Indian Head in the Franconia Notch of the White Mountains. That the artist's work contained a note of prophecy, that it was an immense memorial to a vanishing people, had never, until recently, been brought to the publics' attention. It is, however, from the perusal of ancient manuscripts and the piecing together of fragmented information that the Native Americans, although at first worshipping the stone profile, came later to read their doom in it, far from adoring the face.

From what native tribe the chief came is difficult to ascertain. It is thought by some that he was an Abenaki who had strayed south, but the majority of historians hold that he was possibly a Nipmuk or of a tribe native to the White Hills. No matter what his blood, he was greatly revered by his people, who had the utmost confidence in his prophecies. The chief had derived his name from his first feat in foretelling the future.

An unknown author in the *Granite Monthly* from 1925 provided the following edited excerpts from the article "Falling Mountain: An Indian Chief":

On an early May afternoon, when all the braves were gathered around their village, the chief had appeared suddenly from out of the forest and, with an unusual gleam in his eyes, had summoned all to follow him. Through the dark pines, the small band wound its way until it reached the brow of a hill. Opposing the natives and shutting out the major portion of the sky, was a huge, blue and lofty mountain. The chief stood on a boulder and addressed his people with the following words: "It has been given to me [by] the Great Spirit who dwells in

these mountains from which the whole world is ruled, to know that very soon the side of that great hill will be torn in two. Such are the wonders in Waumbeket Methna."

Even as he spoke, there came a loud rumble from across the valley, growing in volume, shattering the silence that had enveloped the listening Indians. There, on the blue slope of the lofty giant was a great scar widening and running down toward the valley, barely seen through the dusk of grinding rocks, hardly comprehended in the rumble that was filling the whole world. The mountain was falling before their eyes. Fear gripped the braves, and they looked at their chief, whose face was illumined with awe and triumph. Then the thunderous noise began to diminish and the dust to lift toward the sky, leaving a great wound on the side of the mountain. It was that evening around the campfire that the chief had taken his name, Falling Mountain. Since that day, his word had not been questioned.

Leaving the camp on an afternoon in autumn when the huge mountains were splashed with crimson and gold, he wandered until he came into a notch, a passage through the White Hills that was, until now, unknown to him. He was struck by the sheer heights that towered to heaven on either side, for although he had roamed the mountain country all his life, he had never seen a thing like this.

Treading softly up the valley, he came upon a small pond. After lying down to drink, he rose and glanced upward. The expression of his face suddenly became one of dismay. Awestruck, he stepped backward with his eye fastened on the brow of the mountain, rising sheer from the edge of the pond. From the top of that steep hill, a gigantic face was peering out over the wilderness, a profile of mammoth proportions with features of serene love, eternal patience.

It was two days later that a scouting party of braves found him in the shore of a small pond gazing at the Great Stone Face. When the braves saw it, they fell down in fear, asking their chief what it meant. He told them as best he could and directed them to return to the village and move it to this place.

Every night the chief addressed his people in the village and told them why the Great Spirit had carved an image of himself from solid granite. And as he spoke to his people, the Great Stone Face could be seen, high up, fringed with drifting clouds, gazing down the valley, immutable, eternal. It was at such a gathering one evening that a young brave dashed in hurriedly. He was out of breath and frightened. He then pointed to the southwest he told them, "Another face appeared! Looks like me—you—all of us."

It was the face of a man, but not his people. The high forehead, the thin lips, the jutting chin—these had disturbed him secretly, and now to have this brave discover a face like his people.

Indian Head. An impressive profile formed by a ledge on Mount Pemigewasset in North Woodstock, New Hampshire. *Courtesy of the author.*

The face was upturned and with a look of appeal, distress and agony. Tilted back from the forehead were trees, which, at a great distance, appeared as feathers, a headdress dyed with the red and gold of autumn or the red and gold of the warpath.

The two walked back to the village in silence. Darkness fell swiftly. Trembling gleams of lightning toward the west brightened the sky behind the image of the Great Spirit so that it was seen sharp and bold against a background of green light and then suddenly plunged into darkness. The lightning increased, leaping from the finger over the brow of the profile, illumining it for an instant and then disappearing, making it vanish into darkness again.

A storm at this time of the year was unusual, but to have it display the Great Spirit's handiwork with such startling effect was too much. Moreover, the memory of the Indian's profile was distinct in his mind. He could readily see that there was a difference between this face and the one to the southwest.

The storm was working itself into a fury, but in its flashing of lightning, the great face could be seen, high up, peering untroubled with calm strength down the valley. The climax of the storm came in a blinding flash that shot a ball of fire straight out from the finger on the ridge, lighting up the whole notch was a glare as bright as noonday.

Chief Falling Mountain jumped to his feet, crying out with a voice of distress. In the dark recesses of his mind, a light had flashed like a ball of fire, and he had seen clearly the meaning of the finger that spouted fire and the meaning of the Indian's profile that stared, agonized, toward heaven. He called his people together, addressing them with a shaking voice. The patriarch was making the prophecy of his life. He was telling them that the finger was not a finger at all but rather a tool of destruction, meaning no good would come to the terror-stricken Indian to the southwest. Nor did the Great Face behind his back signify any good for his people. The Great Spirit had made both profiles, but the first one found was not his image. He had written a prophecy in the rocks, until now interrupted. With a gesture the old man dismissed the assembled braves. The next day when the sun was shining over the mountain, Chief Falling Mountain gave the order to move the village, and the little band filed northwest.

Historian Ernest E. Bisbee states the following:

It is thought that the band settled on the banks of the St. Lawrence, but whether or not that is so is a matter of conjecture. Of this we are fairly certain: through the medium of the prophet Chief Falling Mountain, the Indians were enabled to read the symbol of their doom in the rocks of Waumbeket Methna.

To this day, those symbols stand. The cannon, perfect in form and elevation, trained over the head of the Old Man of the Mountain, the face of the White Man who peers with calm, determined strength at Indian Head, the features of which have preserved for all time the suffering of the Native Americans. The White Man forces the natives south, north and west. And so the prediction of Chief Falling Mountain came to be fulfilled, long after his death, proving that he had truly read the Great Spirit's meaning in the eternal Profiles of the Rocks.

Indian Head

Historian Ernest E. Bisbee records the following Indian legend:

High above is a profile of an Indian head, an impressive profile formed by a mountain ledge of Mount Pemigewasset. During the War of 1812, the British

stirred up the Abenaquis [sic] Indians, and they made a vicious attack on the settlers, who fled for safety to David Guernsey's blockhouse. It was here that a day's battle took place, but the settlers finally managed to drive the attackers off. Shortly after, the Indians returned to Canada, where it is said that they now make some of the baskets and other Indian souvenirs that are sold on the vary site of the old blockhouse their ancestors fought so hard to win. Guernsey's grandson took it down. Many of the logs were later found to be peppered with the bullets that the Abenaquis [sic] fired in the attack.

Chief Pemigewasset is said to have used the top of the famous Indian Head profile as a lookout for hostile bands of Algonquians who might be traveling up the valley. At that time, the profile as it is seen today was not there, for it was hidden by a growth of tree in the Lincoln forest. A fire swept through the woods one day, and after the fire, the profile of Indian Head could be seen, as though old Chief Pemigewasset himself had come to life again. The actual measurements of the gigantic features are 98 feet from the forehead to the chin, 17 feet across the forehead (up and down), 42 feet along the nose, 23 feet along the upper lip and 16 feet down the chin. The top of the head is 1,330 feet above the level of the highway.

Camping at Indian Head Campground. The campground was considered to be one of the largest overnight tourist camps with an observation tower, circa 1930s. *Courtesy of the author.*

INDIAN LEAP

Historian Ernest E. Bisbee records the following Indian legend:

A short distance from North Woodstock up the Lost River Valley, a mountain water fall rushes through sheer rock walls at a point that is called Indian Leap. Tradition says that the Indians used this place to test the courage and bravery of their young men when they desired to become warriors. They were taken to this place and told to leap across the dark swirling water below. If they hesitated, they were fit only to go and work with the womenfolk. If they jumped and failed to make the opposite bank, they would most likely be drowned, and if they made it to the opposite bank in safety, they were accepted into the ranks of the warriors.

Abenaki observation tower in Melvin Village, New Hampshire, 1930s. *Courtesy of the author.*

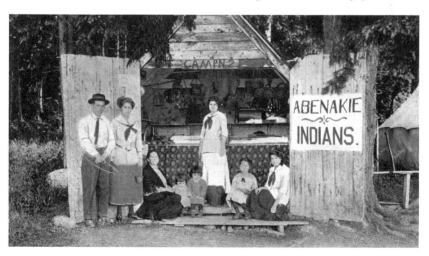

Abenaki Indians camping in the White Mountains, 1930s. *Courtesy of the author.*

A view of Mount Washington (Waumbek Methna). *Courtesy of the author.*

CHOCORUA

Historian Ernest E. Bisbee in *The White Mountains Scrap Book* wrote the following folklore legend of Chief Chocorua and his death:

> *When the Sokosis and Penquaket Indians left for Canada, Chocorua was one of those who refused to leave. He and a few companions remained behind. He became very friendly with an early settler of Tamworth, New Hampshire, by the name of Cornelius Campbell. Mr. Campbell was a very able man, but having been a supporter of Cromwell, he had to flee to America upon the restoration of the king. He sought out this remote valley at the base of what is now known as Mount Chocorua to escape his enemy. Campbell's wife was a lovely woman, and both he and his wife got along very nicely with the Indians who followed Chocorua and regarded him as their prophet.*
>
> *Chocorua had a young son of ten years of age to whom Mrs. Campbell had occasionally given presents and had so won the boy's affection that he was almost a constant visitor to their little farm. So when Chocorua had to go to St. Francis to attend the council of his tribe, he left his son in the care of the Campbells until his return.*
>
> *During his absence, the boy unfortunately discovered some poison that Campbell had prepared to kill foxes with[, and] he drank some of it and died.*

Mount Chocorua and Lake Chocorua. *Courtesy of the author.*

When Chief Chocorua returned, his child had been buried, and he blamed Campbell for killing the boy and swore vengeance. The settler, returning from his work in the field one day, found his wife and children on the floor of the little farm scalped.

The rest of Chocorua's companions happened to be away at the time on a hunting trip, and the settlers had noted that the chief had been climbing to the summit that now bears his name, from time to time to look for signs of their return. So here, finally, Campbell and a party of settlers trailed him and commanded him to throw himself over the precipice on the rocks below. Chocorua replied, "The Great Spirit gave life to Chocorua, and Chocorua will not throw it away at the command of the white man."

"Then hear the Great Spirit speak in the white man's thunder," said Campbell and, firing on him, wounded him badly. Raising himself on his elbow, Chocorua then delivered his famous curse.

In the archive collection of the New Hampshire Folk Tales, Chocorua's curse is given:

A curse upon ye white men! May the Great Spirit curse ye when he speaks in the clouds and his words are fire! Chocorua had a son and ye killed him while

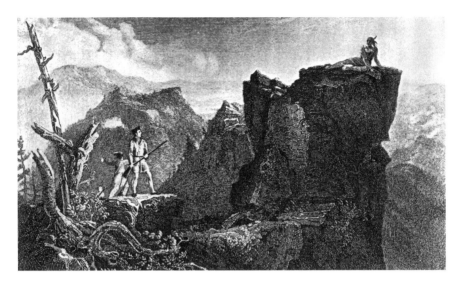

The Death of Chocorua, an engraving of Thomas Cole's painting. *Courtesy of Frederick W. Kilbourne.*

the sky was bright. Lightning blasts your crops! Winds and fire destroy your dwellings! Your graves lie in the warpath of the Indians! Panthers howl and wolves fatten upon your bones! Chocorua goes to the Great Spirit. His curse stays with the white men.

This curse did rest on the settlement for many years. The Indians tomahawked and scalped them. Their crops failed; their cattle sickened and died and, at last, the remnants of the settlement were glad to move elsewhere. To this day, the cattle of the Bear Camp Valley are afflicted with a strange disease. Lately, however, scientists from the university have discovered that it is due to a weak solution of lime in the water, and the remedy prescribed is common soapsuds.

THE SPIRIT OF MOOSILAUKE

It is said that the Great Spirit of the Pemigewasset made his home on Moosilauke, and the Indian had a bold spirit who dared to climb the bald crest of the mountain. William Little recorded the following folk tale of "The Spirit of Moosilauke" in 1876:

They heard him in the voices of the storm and the mighty torrents, and in the thunder that muttered in the dark gorges and rumbled low over the crests. They saw him in the rose hue that kindled on the peaks in early morning, or in the sharp flash of the lightning that leaped from the murky clouds. To him they sacrificed. The first fruit of the chase, the early green maize, the golden salmon, the wild duck, the goose, and the partridge were their offerings.

There was a tradition that a party of Indians followed the Asquamchumauke to its source, and "there they camped beside a beaver pond, where the beaver Tummunk had built houses. These they did not molest but set out just as the sun rose to go over Moosilauke to the Quonnecticut Valley."

The Indians did not often climb the mountains, but when they did, it was only to save time and distance. It was a difficult ascent for the moccasin feet to climb over the stones and through the *hackmatacks*, as they called the dwarf firs and spruces, but on the balk mountain crest, the way was easier.

The legend continues:

When the Natives reached the summit, the heaven, kesuk, was cloudless, and the view was unobstructed. It was a sight the likes of which they had never seen before. Great mountains, wadchu, were piled and scattered in their wildest states over the land; silver lakes, sipes, were sparkling; bright rivers, sepoes, were gleaming from the dense forest below.

As they sat on the summit of the mountain, the wind was chill, and they could hear the moose bellowing in the gorges below and the wolf, musqiushim, howling; and now and then the great war eagle of the mountain, keneu, screamed and hurtled through the air. A feeling of reverence took possession of these Native Americans as they drank in the strange sights and wild primitive sounds, for they believed that the summit was the home of Gitche Manito, the Great Spirit. The untutored Indian was filled with awe as he stood in the dwelling place of his God, afraid that the deity would be angry at the almost sacrilegious invasion.

As the sun was going down in the western sky, a light mist collected around the eastern peaks, and above all the river valleys in the west, clouds assembled. Then thunder began to bellow; the lightning leaped from cloud to cloud; and streams of blinding rays shot down to the hills beneath, while the rain and hailstones, crashing upon the thick woodland, sent up a roar as a hundred mountain torrents: "It is Gitche Manito coming to his home angry."

Joe English

Ms. Elsie Warren compiled the following history of the Indian Legend for the New Boston Chapter, DAR.

Joe English Hill in New Boston is a curious freak of nature. The north ascent is not difficult, and the slope extends a considerable distance. It terminates on the south in a rough precipice two or three hundred feet in height and almost perpendicular. The hill was no doubt a favorite resort for the Indians so long as they lingered in this region. Though New Boston never suffered much from depredations, the settlers lived in fear of roving squads of them.

In 1705–06, there was an Indian living in these parts who was noted for his friendship with the English settlers on the lower Merrimack. He was an accomplished warrior and hunter, but he continued steadfast in his partiality for his white neighbors. Because of this trait, the Indians gave him the name of "Joe English."

In the course of time, the Indians, satisfied that Joe had been giving information of their hostile designs toward the English, determined to kill him at the first fitting opportunity. Accordingly, one day, just at twilight, finding Joe on one of the tree branches hunting. They commenced to attack him. He escaped from them, two or three in number, and ran directly for this hill. With the swift thought of the Indian, he made up his mind that the chances were against him in a long race and he must use deception. As he ran up the hill, he slackened his pace until his pursuers were almost upon him so that they might become more eager in the pursuit. When near the summit of the hill, he started with great rapidity, and the Indians came after him, straining every nerve. As Joe came upon the brink of the precipice, he leaped behind a jutting rock and waited. A moment passed and the hard breathing and light footsteps of his pursuers were heard. In another moment, with a screech and yell, their dark forms were rolling down the rocky precipice to be left at its base, food for hungry wolves. Whereupon the hill was called "Joe English," and well did his friendship deserve so enduring a moment.

Later, he came to his death in consequence of his fidelity to the English settlers. On July 27, 1706, he was acting as a guide to Lieutenant Butterfield and a party of three riding on horseback between Dunstable and Chelmsford, when they fell into an Indian ambush. The main object of the Indians being to secure Joe, the Butterfields made their escape while the Indians went in pursuit of him. A hard race ensued, and Joe had almost gained the thick woods when the Indians, despairing of taking him alive, fired upon him and disabled him. With a yell of triumph, the

Indians came up to him and said, "Now Joe, we got you; you no tell English again we come."

"No," retorted Joe, "Butterfield tell that at Pautucket."

"Hugh!" exclaimed the Indians, the thought just striking them that the soldiers would soon be upon them. There was no time for delay, and a hatchet was buried in the head of the prostrate Indian. Thus died Joe English, faithful friend of the white man. His services were considered of so much value that the legislature of Massachusetts granted his widow and two children land and a home as long as they lived because "he died in the service of his country."

TALES OF WINCHESTER

Among the tales of Winchester that have been handed down from one generation to another but never published is one of Captain Alexander's wife waking up in the night and hearing a baby crying in the taproom. Her husband kept the first tavern in the town, and it was much frequented by the Abenakis when they were not on the warpath. That evening, a large party of Indians had lingered around until late, and when they finally left, the tired tavern innkeeper and his wife went to bed.

Upon descending to the barroom, a small papoose was found lying on a bench where its mother, under the influence of liquor, had left it behind. Mrs. Alexander, who was a motherly soul, took the youngster to bed with her and thus quieted it, and in the morning, she made some gruel. Her elder daughter was feeding it on the kitchen floor when suddenly an Indian and his squaw burst in. One flourished a tomahawk, the other a long knife, and both were intent on avenging what they assumed was the murder of their infant. When they saw the little papoose safe and sound and gurgling with joy over its fine breakfast, they dropped their weapons and danced with joy around the room.

A little later in the season, Captain Alexander's daughter went with a party of young girls to search the ruins of the old church for nails. This church had been burned to the ground in a foray the Indians had made a year or two before, and the nails it had been constructed with were greatly valued because, at that time, all nails were hammered out by hand and were expensive and not too plentiful. While they were engaged, a party of Indians approached them from the nearby woods without being seen and led them all off into captivity. When they reached the Indian encampment, who should see the innkeeper's daughter but the mother of the little papoose the girl had fed on the kitchen floor. The

grateful mother immediately put up a violent protest over the abduction. After they were well fed and cared for that night, she took them back safe and sound early the next morning to their homes, thus once more confirming the old adage that the Indian never forgets a favor not forgives an injury.

New Hampshire Indian Mysteries

The Penobscot and St. Francis Indians were always very friendly and, for many years, used the valley of the Androscoggin, in which the present city of Berlin is located, as a highway between the Indian village in St. Francis, Quebec, and the Penobscot Valley in Maine. For many years, it was a matter of comment among the European white settlers that these two tribes used jasper to sharpen the points of their arrowheads.

Nobody knew of any jasper deposits in this part of the country, and it was not until 1859 that a cave was discovered not far from Berlin where jasper was plentiful. Large heaps of jasper chips lay around where the Indians had flaked their arrowheads from this rock. This cave is fourteen feet long, nine feet high and six feet wide. It seems probable that the entire cave was carved out with incredible labor by the Indians to mine their precious jasper, as no other source of this stone has ever been found near here.

Another mystery was where the Indians obtained the metal they used to make bullets, which when analyzed proved to be more than half silver. This is an early story of a white man and an Indian who were out hunting one day in the vicinity of Berlin Falls and ran out of bullets. The Indian said, "Me get 'um lead but white man no follow Indian. White man sure stay here."

After a lapse of about twelve hours, the Indian returned with plenty of lead, but he would never tell where he had found it. A little later, Uncle Ben Russell, an early settler of Newry, Maine, while hunting in the Androscoggin Valley, became lost and wandered for four or five days before finding his way home. While wandering around and descending the side of a very steep mountain, he threw his small axe ahead of him so that he could more easily climb down. He was surprised that the axe seemed to bury itself in the rock. Upon getting down to it, he found it was embedded in a rich vein of lead, so soft that it could easily be copped out. Taking three or four pounds of it in his knapsack, he sent it to Boston to be analyzed after his return. The report came back that it was more than 60 percent silver, and as that was the analysis of the Indian bullets, here evidently was the source of their supply. Uncle Ben hunted the rest of his life and

never found the vein again. In fact, to this day, a vein of silver and lead still lies undiscovered somewhere in the northern woods of New Hampshire.

In 1604, Pierre Dugua Sieur de Mons, a French merchant, explorer and colonizer, organized an expedition and left France with seventy-four settlers, including royal cartographer Samuel de Champlain, who wrote the following: "The Indians speak of a beautiful river, far to the south, which they call Merrimack."

Between the island and the beach there is the mouth of the Merrimack, where its waters flow past Newburyport into the sea. Its waters flow from New Hampshire's southern boundary into Massachusetts, through Tyngsborough, Lowell, Lawrence, Haverhill and past Newburyport. The Merrimack is wide and powerful.

The Connecticut River, beginning in northern New Hampshire, also flows southward. As is well known, it forms most of the Granite State's western boundary and then crosses the states of Massachusetts and Connecticut. Its total length is 390 miles. The length of the Merrimack is only 150 miles. In the town of Franklin, the Pemigewasset from the Franconia Notch and Lake Winnipesaukee unite to form one river: the Merrimack. From Franklin (Franklin Falls), Merrimack County, the Merrimack River descends between Boscawen and Canterbury, past Concord, between Bow and Pembroke, through Hooksett, past Manchester and Bedford, between Merrimack and Litchfield and Nashua and Hudson. Below Nashua, the Merrimack enters Massachusetts.

From Lake Winnipesauke to the Atlantic Ocean, the Merrimack travels many miles southward and eastward, across the counties of Merrimack and Hillsboro in New Hampshire. In Middlesex and Essex Counties in Massachusetts, the Merrimack drains an area of approximately 4,864 square miles. As it flows southward and eastward, the Contoocook, Suncook, Souhegan, Nashua, Concord, Shawsheen and other streams swell its waters.

The Merrimack River—a river interrupted by rapids and falls, navigable from Newburyport to Haverhill, Massachusetts. The Merrimack's water power became famous throughout the world when vast quantities of cotton grown in the South were spun in the North. Millions of cotton bales were produced annually down South. Many of these bales transmitted into millions of dollars up North, transported from cotton fields to huge factories on the banks of the Merrimack River. The manufacturing cities along this wide and powerful stream—Concord, Manchester, Nashua, Lawrence, Lowell and Haverhill—were famous. From its source to its mouth, the Merrimack heard machines and spindles and saw energy and enterprise.

Possibly, the largest textile mill was the Amoskeag Mills located on the banks of the Merrimack in Manchester.

Still the Merrimack is beautiful, particularly in New Hampshire. Times have changed since 1604, when Sieur de Monts, a French merchant (1564–1628), an explorer and colonizer with a strong influence over the first two decades of the seventeenth century, wrote those opening words. Then the Merrimack ran in primeval beauty from Winnipesaukee to the sea. More than four centuries have passed, and this mighty river is still beautiful.

Spear Fishing

Ancient artifacts show Native Americans in various poses in the act of casting spears at the fish beneath the water. This method of fishing was very popular at the channel outlet of the lake at the Weirs in Lake Winnipesaukee.

Many fishermen today claim there is very little sport in spear fishing and very little skill in outwitting the quarry. For many, fooling the fish into striking a lure is the ultimate fishing thrill. Opponents of spear fishing add that some fish escape

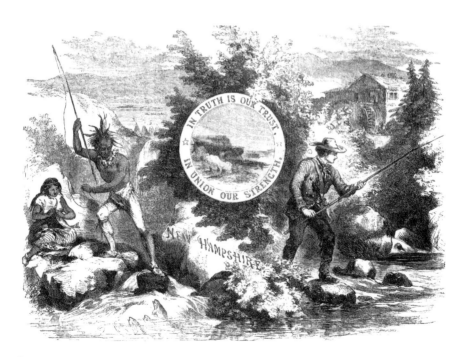

Spear fishing. "In truth is our trust, in union our strength." *Left*: An Abenaki family; *right*: an early English settler. *Courtesy of the author.*

from the spear after being wounded. Many fishermen also claim that it is a very bloody sport, but so is hook-and-line fishing, particularly if live bait is used and the fish swallow hook and all.

Basically, the difference in the two types of fishing is that in lure fishing, you fool the fish into striking something on which it gets hooked, while in spear fishing, you lure it close enough to put a huge, six-tined spear through it. They tell me that there is a tremendous thrill in fighting a fish on a line that you don't get on a spear, but on the other hand, the first thirty seconds after pulling up a thrashing twenty-pound pike inside a little shanty is not exactly boring. The Indians were very successful with the spear, for they knew that most spearing was done in fairly shallow water. Another method of spear fishing in shallow water was from a shanty that was completely dark inside. The fisherman would dress in dark clothing to cut down on the possibility of a sharp-eyed pike spotting movement. The darkness permitted the fisherman to see down the to ice hole during winter fishing. The fisherman waited for a fish to swim slowly by, or he decoyed it into a position in which it could be speared.

According to the Native Americans' legend and tradition, there is a right and wrong way to spear fish. Tradition has it that

> *the right way is to throw the spear at the fish to increase your chance of a good hit. The spear should be positioned so that it is at a right angle to the length of the fish's back. Try to place the spear just in back of the bill covers; this seems to be the most vulnerable spot, especially on larger fish. A spear penetrating the backbone has a particularly paralyzing effect. The exact spot is not so critical on smaller fish, just so long as the spear penetrates enough to hold it.*

To increase your chances at spearing a fish, you may use decoys to attract the unsuspecting fish within striking range, as the Abenakis and Sokokis did. There are several kinds of decoys, but they all fall into two principal categories: live fish decoys and artificial fish decoys. Live decoys are preferred by most Indians in New Hampshire. The natural scent of live fish is more attractive than the paint and varnish of an artificial lure. It is said that pike are the most common target for the fisherman in New England. Pike feed in water of practically any depth, but they can best be seen to be speared in shallow water. They particularly enjoy hanging among weed beds where smaller fish hide.

The tradition continues:

> *Other large species are usually lured and speared much in the same way as the northern pike. There may be more restrictions on spear fishing today as*

compared with the Indian methods for certain species such as muskies, bass and trout. In fact, it is almost unheard of to spear a trout or a largemouth bass today—check the regulations with your fish and game department. You must keep track of the regulations year by year because in certain New England states spear fishing is banned.

Because of the feeding habits of the biggest of all our fishes, the sturgeon, there is a good chance that fishing for those monsters by spear may continue. Sturgeon are strictly bottom feeders and are hooked by a hand line only by accident. About the only way these huge creatures are taken is by spearing them through the ice during a short winter season.

Lake Winnipesaukee

The lake is steeped with Indian folklore and legends of how it got its name. Here is one story of the origin of the lake's name. Seldom does the summer go by that visitors have not found relics of early Indian hunting or camping grounds. This may be so because the greatest activity of the Indians took

Profile Rock on Eagle Island in Lake Winnipesaukee. *Courtesy of the author.*

place on the west shore at the Weirs and Meredith, where the Aquadoctan settlement was located.

Aquadoctan, a Sokoki name, means "the Weirs." The Weirs derived its name from an Indian fishing weir, which was a triangular enclosure of rocks long used for trapping fish. The weir permitted the water to flow freely down the channel but trapped the shad in this triangular network of logs and stone. It is said that this fishing weir, located near the Endicott Rock, may still be seen in those deep waters.

Native fishermen tell us that the shad make their rushing at the Weirs on about June 1 and that this run lasts for about two weeks. Buy use of this weir and nets, tons of fish were acquired by the Aquadoctans. These people had many camping and hunting grounds throughout the Lakes Region, some of them being at the Pemigewasset Lakes, Wakewan, Moultonborough, Wolfeborough, Alton Bay, Lake Wicwas and many of the smaller ponds.

Of all the all the tales about the local Indians in the Lakes Region, this tale seems to gather more attention than most and comes from the small village of New Halem, presently known as Meredith, the hunting grounds of the Winnipesaukee tribes.

Réjean OBomsawin, cultural director of Obanak Village in Quebec, Canada, and Dr. Bruce D. Heald, author. *Courtesy of the author.*

It was Ahanton, who was known for his warlike courage in his tribe, who had a daughter by the name of Ellacoya. She was a fair maiden known far and wide, who was unable to have a suitor because of her father's dislike for them. It was because of these rumors that the young chieftain south of the lake, Kona (Eagle), decided to test his skill and win the hand and heart of this fair maiden. Dressed in full costume, the young brave arrived at the encampment while Ellacoya's father was away and is said to have immediately won the her heart. When her father returned, he was angered to discover their attachment. With a sharp cry, he made an attack on the young brave Kona for daring to woo his daughter and knowingly taking advantage of his absence. Ellacoya, possessed with great love for Kona, thrust herself between the angry men and pleaded for the life of Kona, telling her father of his display of courage when he fearlessly entered the village. Ahanton, being an admirer of courage and bravery, admitted his haste, whereupon Kona asked for the maiden's hand and was proudly granted the request by the great warrior. Many celebrations were held through the region, and many feasts were had.

It is said that while Ellacoya and Kona were traveling across this mirror lake, a dark cloud concealed the rays of the sun and a threatening storm began to turn the water black. Just at the moment when the party was ready to turn back for safety, the sun shone through, guiding the two lovers safely to the other side of the lake.

"Here," cried Ahanton, "is the smile of the Great Spirit."

APPENDIX

A Timeline of New Hampshire Indian History

It is well known that for thousands of years, the Native Americans occupied this land in America. The indigenous Indian people were the first to meet the European settlers. With them, the Europeans brought new tools for labor, customs, religion, weapons, livestock and disease, which profoundly affected the history and welfare of the American Indians

We have created a timeline that provides the dates of conflicts, wars and battles involving the New Hampshire Indians.

1636: The New Hampshire colony was founded by John Mason and established by John Wheelwright and others.
1688–1763: The French and Indian Wars between France and Great Britain for land in North America, consisting of King William's War (1688–99), Queen Anne's War (1702–13), King George's War (1744–48) and the French and Indian War, also known as the Seven Years' War (1754–63).
1763: Treaty of Paris.
1775–83: The American Revolution.
1776: The Declaration of Independence.
1803: The Louisiana Purchase. The United States bought the Louisiana Territory from France for $15 million.
1830: Indian Removal Act.
1832: The Department of Indian Affairs was established.

1887: Dawes's General Allotment Act, passed by Congress, led to the break-up of the large Indian Reservations and the sale of Indian lands to white settlers.

1969: All Indians declared citizens of the United States.

1979: American Indian Religious Freedom Act passed.

WESTERN AND EASTERN ABENAKIS NATION

Historically, ethnologists have classified the Abenakis as geographical groups: the western Abenakis and eastern Abenakis. Within these groups are listed the following bands:

The Western Abenakis

Amoskeays

Arisgantegoks: This band lived along the St. Francis River in Quebec. The principal village was St. Francis Odanak. They are known as the St. Francis River Abenakis, and according to historian Colin G. Calloway's *The Western Abenakis of Vermont, 1600–1800*, the war migration and the survival of an Indian tribe was to be applied to all western Abenaki people.

Arosaguntacooks

Cochecos

Cosasucks: "People of the Pines." This band lived in the upper Connecticut River Valley. The principal village was Cowass, near Newbury, Vermont.

Cowasuks (Coos)

Missiquois: "People of the Flint." This band lived in the Missisquoi Valley from Lake Champlain to the headwaters. The main village was Swanton, Vermont. They are also known as Sokokis.

Nashuas: "Old Philips Band," presently known as the Nulhegan tribe. This band inhabited Lake Memphremagog, Nulhegan Basin and the territories covered by the Philips Grant, which goes through the upper New Hampshire territory, Indian Stream and over to Moosehead Lake in Maine.

Ossipees: This band lived along the shores of Ossipee Lake due east of the Ossipee Mountain Range in Central New Hampshire. They were often classified as eastern Abenakis.

Pemigewassets

Pennacooks (Penacooks): This band lived in the Merrimack Valley along the Merrimack River. The main villages were Penacook and Concord, New Hampshire.

Pequawkets: This band lived along the Saco River and in the White Mountains. The main village was located on the upper Saco River near Fryeburg, Maine. Since they lived in the middle of the eastern and western territories, they were often classified as eastern Abenakis.

Piscataquas

Souhegans

St. Francis River Abenakis

Winnipesaukees: "The region of the land around lakes." This band lived along the shores of Lake Winnipesaukee, New Hampshire.

The Eastern Abenakis

Amesecontis: This band lived between the upper Kennebec and Androscoggin Rivers in western Maine.

Androscoggins: This band lived in the Androscoggin Valley and along the St. Francis River and are therefore often called St. Francis River Abenakis.

Apikwahkis

Kennebecs, later known as Norridgewocks: This band lived in the Kenneebec River Valley in northern Maine. The main village was Norridgewock.

Kwupahags.

Odanaks (also known as the St. Francis du Lac): This band lived southwest of Trois Rivieres, Quebec, Canada.

Ossipees: This band lived in Ossipee, New Hampshire

Penobscots: This band lived in the Penobscot Valley. The main villages were Indian Island; Old Town, Maine; and several others.

Rocamecas: This band lived in the coastal areas of southern Maine.

Wabigganus: This group of the Penobscot Indians band is presently considered a separate tribe.

Wolinaks: This band lived around Trois-Rivieres, Quebec.

ANCIENT INDIAN VILLAGES IN NEW HAMPSHIRE

Most of the villages were abandoned prior to 1685.

Aquadoctan, the Weirs
Aroosabaug, Mirror Lake
Ashueiot, Swaney, New Hampshire

Chategway (Chateguay), Conway, New Hampshire
Chemung, Farmington, New Hampshire
Chenavok, Moultonborough Neck, New Hampshire
Cocheco, Dover, New Hampshire
Cohas Brook, Manchester, New Hampshire

Massabesic Island
Massapaug, Great Pond, Kingston, New Hampshire

Namaskik, Namakeag, Manchester, New Hampshire
Nipmuk, Richmond, New Hampshire

Odell Park, Franklin, New Hampshire
O'quasakikonaguan, Newbury, New Hampshire
Ordanakia, Lyme, New Hampshire
Ossipee, Ossipee Lake, New Hampshire

Pasaguaney (Passaguanik), Bristol, New Hampshire
Pemigewasset, Plymouth, New Hampshire
Penacook, Concord, New Hampshire
Philips Pond, Sandown, New Hampshire
Pisgatock, Somersworth, New Hampshire

Senikok, Gilmanton Iron Works, New Hampshire
Sowcook, Litchfield, New Hampshire
Squakheag, Hinesdale, New Hampshire
Squamanagonic, Gonic, New Hampshire
Squamascott, Exeter, New Hampshire

Quannippi, Alton Bay, New Hampshire

Washucke, Wadley Falls, Lee, New Hampshire
Watanie, (Nissawog), Nashua, New Hampshire
Winnicutt, Great Bay, Greenland, New Hampshire

ABENAKI WORDS AND THEIR MEANINGS

A close examination of Indian names finds these words used quite often in the Abenaki language. Several words that form compound names are important:

Asquam was a broad sheet of water.
Aukee was a high place, mountain or hill.
Cook was a quiet (rather than rapid) stretch in a stream.
Keag was a fishing ground.
Mag or *mass* meant large, big or high.
Nipi was a lake.
Tegu or *tegwu* was a river.

Ammonoosuc: "A narrow fishing place," from *namos*, "fish," and *noo*, "narrow."
Amoskeag: Formerly this was *Nameskeag. Names* was the word for "fish" and *makuamaga* was the word for "salmon." This was the gathering place for the Indians at the fall.
Asquam: The name is an abbreviation of Wonnesquam sauke. *Wenne* or *winne* means smiling. The *Winneasquam-s-auke* means "smiling big sheet of water surrounded by mountains."
Asquamachumauke: This was the Indian name for the Baker River, which rises near Mount Moosilauke. *Asquam* means "big or much water," *chum* means "crooked" and *auke*, "from a mountain." At Plymouth, where the stream joins the Pemigewasset River, several brooks flowed from the hills into the Pemigewasset, but this was the big water, greater than the others. The tribe called Pemigewasset lived around these waters.
Awasoswi Menahan: The Indian name of Bear Island, Lake Winnipesaukee.

Cocheco: "The rapid foaming river." The city of Dover is located at the falls, but early settlers extended the name to the whole river.
Connecticut: An Anglicized pronunciation from the Indian name *Keweni-tegu* or *tegwu. Keweni* meant "long"—the longest river in New England.

Contoocock: The syllable *con* may be the same as in Connecticut, and the word may mean "a long, quiet place," as it is in spots almost a lake in appearance.

Coos: The name of the most northern country derived it name from the tribe that was living along the valley of the Connecticut River, especially at the ox-bow or bend of the river at Lancaster and Haverhill where the natural meadows and flood plains provided fields for growing Indian corn. *Coas* or *cohas* was a pine forest covering the landscape. Formerly, the name was spelled with extra letters, *cohos* or *coohos*.

Cusmpe: This is the name of a small lake near Big Squam, and long ago, the lake was possibly part of Big Squam.

Mascoma: "Place of the bear." This word was contracted from *awasos-auke*, "bear place."

Merrimack: Like Connecticut, here is a greatly changed name. One word for bear in Abenaki was *misha*, and *mag* meant big. *Misha mag* was the Great Bear or the totem of the Abenakis, as formerly stated. *Misha mag* finally became "Merri-mac" to the English settlers.

Monadnock: The Indians called the white man's money *mona*, for "silver." *Mona-auke* meant "silver mountain."

Mooailauke: This is the most northern mountain with an Indian name. Its summit is bare granite. The word for bald was *moo*, which was combined with *auke* to mean "a bald or bare high place."

Newichawannock: Name of the place where Dover is located today, meaning "Wigwam Place."

Opechee: *Sipe* was the word for bird, and this name is thought to mean Robin Lake.

Ossipee: "A pine tree lake." Formed from *coos* and *nipi*.

Pasquane: Newfound Lake was called Pasquane. *Masqua* was birch bark. This name probably ended in *nini* and meant the "lake of the birch or canoe tree."

Pemigewasset: This was the name of a famous Indian chief who lived around five hundred years ago. The word *pamijewaski* meant "swift or rapid current" and is claimed to be the original for the name of the river.

Penacook: *Penna* was another word for "winding" or "crooked"; a *cook* was a broad, quiet place in a river, such as the section of the Merrimack that quietly flows through the meadow of Penacook and Concord where the tribe of this name lived.

Pequaket: Name of a tribe, said to mean "Crooked Place."

Piscataqua: Divided tidal river.

Saco: South outlet.

Souhegan: Name of a tribe called "Meadow-men," also meant "south opening."

Squam: Two lakes are called Big and Little Squam. Before the forest was gone, the two were probably one lake.

Squanamanagonic (Gonic): "Water from the clay-place hill." A village in Rochester.

Squanscoot (asquam-scott): "Big Water Place." Exeter and the Great Bay.

Suncook: *Suna* was the word for "wild goose," and this name may possible mean wild goose place. (Also *sun* may mean "stony river.")

Sunapee: "Wild goose water or lake."

Waukewan: Wigwam.

Wickwas: Wequash, originally.

Winnipesaukee: This name is composed of *Wini-s-aukee*, which means "smiling lake between the mountains." Geologists chaim that long ago, the lake flowed south into the Cocheco River. Now it flows through the Winnipesaukee River in Franklin, and the two form the present Merrimack River.

Winnipeseogee: The name divided into syllables is *win-nipe-see-gee*, meaning "smiling lake of the Great Spirit." The final *gee* or *jee* is the Abenaki word for God. This is considered to be the same root word of Jehovah of the Hebrew, Jupiter of the Romans and Zeus of the Greeks. However, Chester B. Price, in his 1967 article "Historic Indian Trails of New Hampshire," wrote that according to the eminent Indianologist Father Jeremiah O'Brien, who spent several months at the Indian reservations, "Winnipesaukee is actually a derivation from the Indian word Wiwininebesaki, which means 'at the lake in the vicinity of which there are other lakes and ponds,' or literally, 'Lakes Region.'" The present spelling of Winnipsaukee was made official by the New Hampshire legislature in 1933. Here are two other ways I have found it spelled: Winnifsoikee and Winnipisseoke. There are 132 variations of the Winnipesaukee Indian spelling from the *Dictionary of American Indian Names* by R.A. Douglas-Lithgow.

Winnisquam: "Smiling big water."

Winona: Name of an Indian maiden who talked with the birds.

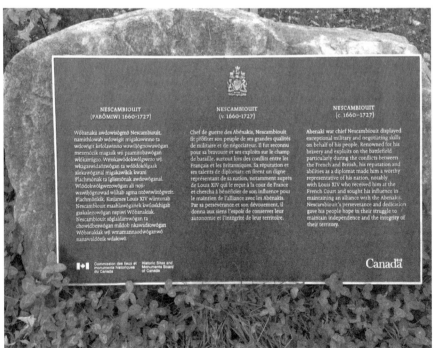

NESCAMBIOUIT
(PABÔMIWI 1660-1727)

Wôbanakii awdowisôgmô Nescambiouit, namithlowab wdowigit migakawinno ta wdowigit kelolawinno wawiljôgnowawôgan mezenôzik magaiık wji paamitobawôgan wlôkamigzo. Wmiskawôdokwôlgwezo wji wkagaswidaôzwôgan ta wdôdokôlgaak alokawôganal migakawikik kwani Plachmônak ta Iglismônak awdowôganal. Wlôdokwôlgwezowôgan ali noji-wawiljôgnowad wlihab agma ntôwtwlitôgwzit. Plachmônkik, Kinjames Louis XIV wlintonab Nescambiouit maahlawôganek kwiloskhigab gaskalegowôgan nspiwi Wôbanakiak. Nescambiouit sôglaldamwôgan ta chowidbeswôgan mildob nkawadsowôgan Wôbanakiak wji wmamannaodwôganwô nanawaldôzik wdakiwô.

NESCAMBIOUIT
(v. 1660-1727)

Chef de guerre des Abénakis, Nescambiouit fit profiter son peuple de ses grandes qualités de militaire et de négociateur. Il fut reconnu pour sa bravoure et ses exploits sur le champ de bataille, surtout lors des conflits entre les Français et les Britanniques. Sa réputation et ses talents de diplomate en firent un digne représentant de sa nation, notamment auprès de Louis XIV qui le reçut à la cour de France et chercha à bénéficier de son influence pour le maintien de l'alliance avec les Abénakis. Par sa persévérance et son dévouement, il donna aux siens l'espoir de conserver leur autonomie et l'intégrité de leur territoire.

NESCAMBIOUIT
(c. 1660–1727)

Abenaki war chief Nescambiouit displayed exceptional military and negotiating skills on behalf of his people. Renowned for his bravery and exploits on the battlefield particularly during the conflicts between the French and British, his reputation and abilities as a diplomat made him a worthy representative of his nation, notably with Louis XIV who received him at the French Court and sought his influence in maintaining an alliance with the Abenakis. Nescambiouit's perseverance and dedication gave his people hope in their struggle to maintain independence and the integrity of their territory.

Commission des lieux et monuments historiques du Canada / Historic Sites and Monuments Board of Canada

Canada

Indian chief Donald Stevens and his mother of the Nulhegan Band of the Coosuk-Abenaki Nation at the yearly powwow, 2013. *Courtesy of Chief Donald Stevens.*

Opposite, top: *The Last of His Race.* Painting of a Native American in the White Mountains. *Courtesy of the author.*

Opposite, bottom: Historic sites and monuments board of Canada. Nescambiouit (circa 1660–1727). *Courtesy of Réjean OBomsawin, director of Cultural Affairs of Odanak Village, Quebec, Canada.*

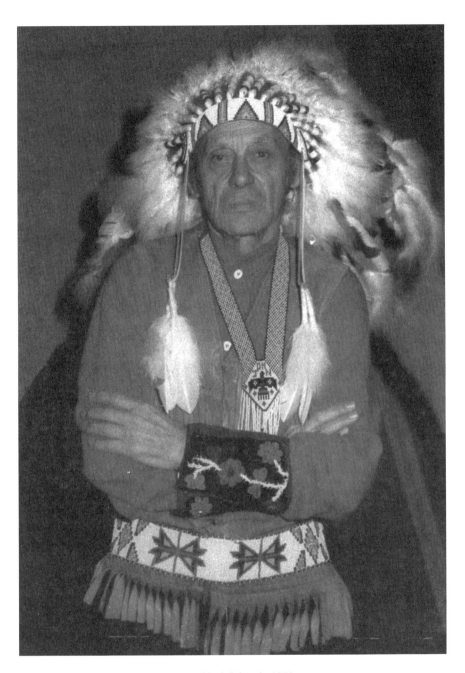

Albert Obomsawin, chief of the Abenaki of Odanak, 1985.

BIBLIOGRAPHY

Allitt, Patrick. "City on a Hill." *New York Times*, 2007.

Anonymous. *The First Language of New Hampshire*. Concord: New Hampshire Profile, 1958.

———. "An Indian Prophecy." *Granite Monthly* (May 1925).

———. "Merrimack by the River." *Granite State Magazine* 2 (1906).

———. *New Hampshire Folk Tales*. Concord: New Hampshire Historical Society, n.d.

———. "Schunk the Loon." *Granite Monthly* (January 1904).

Bass, Cora C. "Where Passaconnaway Was Wont Stand." *Granite State Magazine* 1 (1906).

Belknap, Jeremy. *The History of New Hampshire*. 3 vols. Philadelphia: Robert Aitken, 1784.

Bisbee, Ernest E. *The White Mountain Scrap Book*. Lancaster, NH: Bisbee Press, 1946.

Calloway, Colin G. *The Western Abenaki of Vermont, 1600–1800*. Norman: University of Oklahoma Press, 1994.

Calvert, Mary R. *Dawn over the Kennebec*. Monmouth, ME: Monmouth Press, 1983.

Chapdelaine, Claude. "Des Chasseurs de la Fin de l'Age Glaiaire dans la Region due lac Megantic: Decouvertes des Premieeres Pointes a Cannelure au Quebec." *Recherches Amerindienne au Quebec* 34, no. 1 (2004): 3–20.

———. "Presentation. Sur les Traces des Premiers Quebecois." *Recherches Amerindiennes au Quebec* 15, nos. 1–2 (1985): 3–6.

Colby, Solon B. *Colby's Indian History*. Meredith, NH: Solon B. Colby, 1975.

Constitution of the Sovereign Republic of the Abenaki Nation of Missisquoi.

Copway, George. "Pastimes of the Indians." *Granite State Magazine* 2 (1906).

Cutter, Barbara. "The Female Indian Killer Memorialized: Hannah Duston and the Nineteenth-Century Feminization of America Violence." *Journal of Women's History* 20, no. 2 (Summer 2008): 10–33.

Douglas-Lithgow, Robert Alexander. *Dictionary of American Indian Names*. Salem, MA: Salem Press, 1909.

Drake, Samuel A. *The Heart of the White Mountains*. New York: Harper & Brothers, Franklin Press, 1882.

Dumais, Pierre, and Gilles Rousseau. "De Limon et de Sable, une Occupation Paleoindienne du Debut de l'Holocene a Squantec (CIEe-9) au Temiscouata." *Recherches Amerindiennes au Quebec* 32, no. 3 (2002): 55–75.

Fassett, James H. *Colonial Life in New Hampshire*. Boston: Ginn & Company, 1899.

Goodwin, M. B., editor. *Merrimack Journal*, 1872.

Gookin, Daniel. *Historical Collection of the Indians of New England: Of Their Several Nations, Numbers, Customs, Manners, Religion and Government...* Boston: Gookin's collection, 1674.

Gordon, M. Day. "Dartmouth and Saint Francis." *Dartmouth Alumni Magazine* 52, no. 2 (November 1959).

———. "The Identities of Sokokis." *Ethnohistory* 12 (1965).

Grenier, John. *The First Way of War*. Cambridge, UK: University of Cambridge Press, 2005.

Griffin, S.S. "Indian Legend." *Granite State Magazine* 1 (1906).

Heald, Bruce D. *Follow the Mount*. Weirs Beach, NH: Winnipesaukee Flagship Co., 2000.

———. *The Making of America: Lake Winnipesaukee*. Charleston, SC: Arcadia Publishing, 2001.

———. *Reminisce the Valley: The Lakes Region of New Hampshire*. Weirs Beach, NH: Weirs Publishing Co., 2002.

Hyde, Dorsey W. "A Great Indian Battle." *New Hampshire Profile Magazine* (June 1953).

Kilbourne, Frederick W. *Chronicles of the White Mountains*. Boston: Houghton, Mifflin Co., 1916.

King, Thomas Starr. *The White Hills*. Boston: Crosby & Ainsworth, 1866.

Laurent, Stephen. *Father Aubery's French Abenaki Dictionary*. Portland, ME: Chisholm Bros., 1995.

Little, Gene. *Ice Fishing*. Boston: Book Brothers, Inc., 1975.

Little, William. *The White Mountains*. New York: James R. Osgood and Company, 1876.

Mather, Cotton. *Magnalia Christi Americana, or the Ecclesiastical History of New England from 1620–1698*. Boston, 1702.

Military Records. "Cocheco's the Waldron Massacre." *Granite Monthly* 4, no. 3 (1907).

Musgrove, Richard W. *History of the Town of Bristol, Grafton County, New Hampshire*. Bristol, NH: Richard W. Musgrove, 1904.

Obomsawin, Réjean. "Site Cliché-Rancourt (BiEr-14) of the Abenakis Band of Odanak, Quebec Region, Canada." 2013.

Pillsbury, Hobart. *New Hampshire a History*. New York: Lewis Historical Publishing Co., 1927.

Pintal, Jean-Yves, "De la Nature des Occupation Paleoindiennes a l'embouchure de la Riviere Chaudiere." *Recherches Amerindiennes au Quebec* 32, no. 3 (2002): 41–54.

Potter, Chandler E. "Last of the Penacooks." *Granite State Magazine* 1 (January 1906).

Proctor, Mary A. *The Indians of the Winnipesaukee and Pemigewasset Valley*. Franklin, NH: Towne & Robie, 1930.

Rosal, Lorenca C. *God Save the People*. Orford, NH: Equity Publishing Corporation, 1988.

Sandborn, A.H. *Amoskeag Falls in the Winter*. Vol. 1. Manchester, NH: Granite State Publishing, Co., 1906.

Scales, John. "The Passcataqua River." *Granite State Magazine* 2 (1906).

Speare, Eva A. *Indians of New Hampshire*. Littleton, NH: Courier Presse, 1960.

Upham, George B. "An Indian Fight." *Granite Monthly* (September 1919).

Waldman, Carl. *Encyclopedia of Native American Tribes*. 3rd ed. New York: Facts on File, 2006.

Wilcomb, Edgar Harlan. *Lake Country Gleanings: Rambles about the Weirs*. Worcester, MA: Worcester Press, 1923.

Williamson, William. *History of Maine*. Bangor: Maine Historical Society, 1832.

Wright, James V. *Quebec Prehistory*. Ottawa: National Museums of Canada, 1979.

INDEX

A

Algonquians 15
Allitt, Patrick 66
Amoskeag 16, 58, 59, 106, 115
Assacumbit 39

B

Baker River 32, 55, 58, 115
Barber's Mountain 74
Belknap, Jeremy 18, 71
Bigot, James 29
Boucher, Pierre 50, 51

C

Champlain 16, 22, 30, 43, 51, 60, 79,
 105, 112
Cocheco 31, 38, 67, 112, 114, 115, 117
Colby, Solon 11, 32, 54, 81, 82
Connecticut 16, 19, 24, 30, 37, 52, 53,
 58, 62, 72, 73, 75, 84, 87, 105,
 112, 115
Conway 24, 43, 82, 114
custom 24, 27, 34, 35, 53, 82, 111

D

Duston, Hannah 66

E

Eliot, John 20, 36, 37, 46, 47, 49
English, Joe 102, 103

F

Fort No. 4 78
Fryeburg, Maine 32, 54, 57, 83, 113

G

garrison 64, 67, 70, 71, 80, 85
Gilmanton 32, 60, 79, 86, 114

I

Iroquois 15, 21, 42

J

Jesuit 7, 20, 21, 46, 47, 50, 51
Johnson, Captain 78
Josselyn, John 30

K

Kancamagus 32, 38, 55, 67

L

Laconia 32, 33, 57
Laurent, Stephen 18, 41, 43
Livermore Falls 56

M

manitou 29
Mather, Cotton 39, 49, 66
Mayhew 20
Meredith 33, 58, 81, 109, 122
Merrimack 16, 24, 32, 33, 36, 37, 53,
 57, 59, 60, 66, 67, 80, 86, 102,
 105, 113, 116
Micmac 16, 60
Mohawk 16, 20, 21, 24, 33, 38, 54,
 60, 80
Montreal 30, 34, 50, 77
Moosilauke 115
Moultonborough 32, 109, 114

N

Naticook 19
Nulhegan 13, 27, 52, 112

O

Obomsawin, Réjean 7, 11, 34, 89, 123
Odanak 7, 20, 23, 34, 41, 51, 52, 89,
 112, 113, 123
Oganwinno 22
Old Man of the Mountain 95
Ossipee 11, 16, 32, 33, 54, 57, 61, 83,
 112, 114, 116
Ottawas 21
Oyster River 70

P

Pascataqua River 67
Passaconaway 20, 35, 36
Paugus 33

Pemigewasset 30, 33, 44, 54, 55, 58,
 87, 95, 96, 100, 105, 109, 113,
 114, 116
Pennacook 11, 15, 19, 21, 24, 36, 37,
 38, 51, 57, 59, 60, 66, 80, 113,
 114, 116
Pike, John 69
Pillsbury 70
Plymouth 32, 35, 55, 58, 114
powwow 27, 35, 39
Proctor, Mary 44

Q

Queen Anne's War 60, 111

R

Rale, Sébastien 84
Ralle 79

S

Saco 16, 19, 24, 32, 57, 60, 85, 113, 117
Salmon Falls 69
Sieur de Monts 106
Sokokis 5, 7, 16, 18, 19, 21, 22, 30, 44,
 61, 62, 83, 84, 88, 107, 112, 122
spear fishing 106, 107
Squando 38
Stark, John 52, 58
Stevens, Donald 13, 27, 52
St. Francis 20, 21, 22, 30, 37, 38, 41,
 50, 51, 79, 84, 88, 98, 104, 112
Suncook 19, 33, 105, 117

W

Wabanaki 16, 24
Waldron, Major 67, 85
Waumbek Methna 90
Weirs, the 24, 26, 32, 57, 81, 88, 106,
 109, 114, 123
White Mountains 24, 30, 32, 39, 57,
 88, 91, 113, 122
wigwam 22, 26, 32, 37, 38, 48, 54,
 116, 117

Winnipesaukee 16, 24, 30, 32, 44, 54,
 57, 58, 59, 79, 81, 85, 106, 113,
 115, 117, 123
Wobanaki 7, 19
Wolfeborough 32, 109
Wonalancet 20, 21, 67
Wright, Benjamin 74
Wright, Jim 34

ABOUT THE AUTHOR

B ruce Heald is an adjunct professor of American history for the History and Philosophy Department at Plymouth State University; an associate professor at Babes-Bylyai University in Cluj-Napoca, Romania; a periodic lecturer of "Wars in U.S. History" at West Point; a senior purser aboard the MS *Mount Washington*; and the author of over forty books and numerous articles about the history of New England.

Dr. Heald is a graduate of Boston University, University of Massachusetts–Lowell and Columbia Pacific University. He is presently a fellow in the International Biographical Association and the World Literary Academy in Cambridge, England. Dr. Heald was the recipient of the Gold Medal of Honor for literary achievement from the American Biographical Institute in 1993. From 2005 to 2008, he was a state representative to the general court of New Hampshire. Dr. Heald resides in Meredith, New Hampshire, with his family.